THE VISIONS OF
TONDAL
FROM THE LIBRARY OF
MARGARET OF YORK

THE VISIONS OF
TONDAL
FROM THE LIBRARY OF
MARGARET OF YORK

Thomas Kren

Roger S. Wieck

The J. Paul Getty Museum Malibu, California 1990

© 1990 The J. Paul Getty Museum
17985 Pacific Coast Highway
Malibu, California 90265
Mailing address:
P.O. Box 2112
Santa Monica, California 90406

Christopher Hudson, Head of Publications
Cynthia Newman Helms, Managing Editor
Karen Schmidt, Production Manager
John Harris, Editor
Kurt Hauser, Designer
Thea Piegdon, Production Artist
Charles Passela, Photographer

Figure 4 drawn by Beverly Lazor-Bahr
Typography by Wilsted & Taylor
Printed by Gardner Lithograph

Unless otherwise indicated, all photographs are courtesy of the
institution that owns the work illustrated.

Cover: *The Beast Acheron, Devourer of the Avaricious* (detail). From
The Visions of Tondal. Malibu, J. Paul Getty Museum, Ms. 30
(pl. 7).

Library of Congress Cataloging-in-Publication Data
Kren, Thomas, 1950–
The Visions of Tondal from the library of Margaret of York /
Thomas Kren, Roger S. Wieck.
 p. cm.
 Includes bibliographical references.
 Contents: The Visions of Tondal and the visionary tradition in
the Middle Ages / Roger S. Wieck—The library of Margaret of
York and the Burgundian court / Thomas Kren—The Visions of
Tondal, the art of Simon Marmion, and Burgundian illumination of
the 1470s / Thomas Kren—The Visions of Tondal : text and
miniatures.
 ISBN 0-89236-169-7
 1. Visio Tnugdali. 2. Visions in literature. 3. Voyages to the
otherworld in literature. 4. Devotional literature, French—
Translations into English—Manuscripts. 5. Devotional literature,
English—Translations from French—Manuscripts. 6. Margaret of
York, Duchess, consort of Charles the Bold, Duke of Burgundy,
1446–1503—Library. 7. Illumination of books and manuscripts,
Flemish. 8. Manuscripts, Medieval—France—Burgundy.
9. Voyages to the otherworld in art. 10. Marmion, Simon,
1420–1489. I. Wieck, Roger S. II. J. Paul Getty Museum.
III. Visio Tnugdali. Selections. English. 1990. IV. Title.
PQ1595.V553K74 1990
873'.03—dc20 89-48423
 CIP

CONTENTS

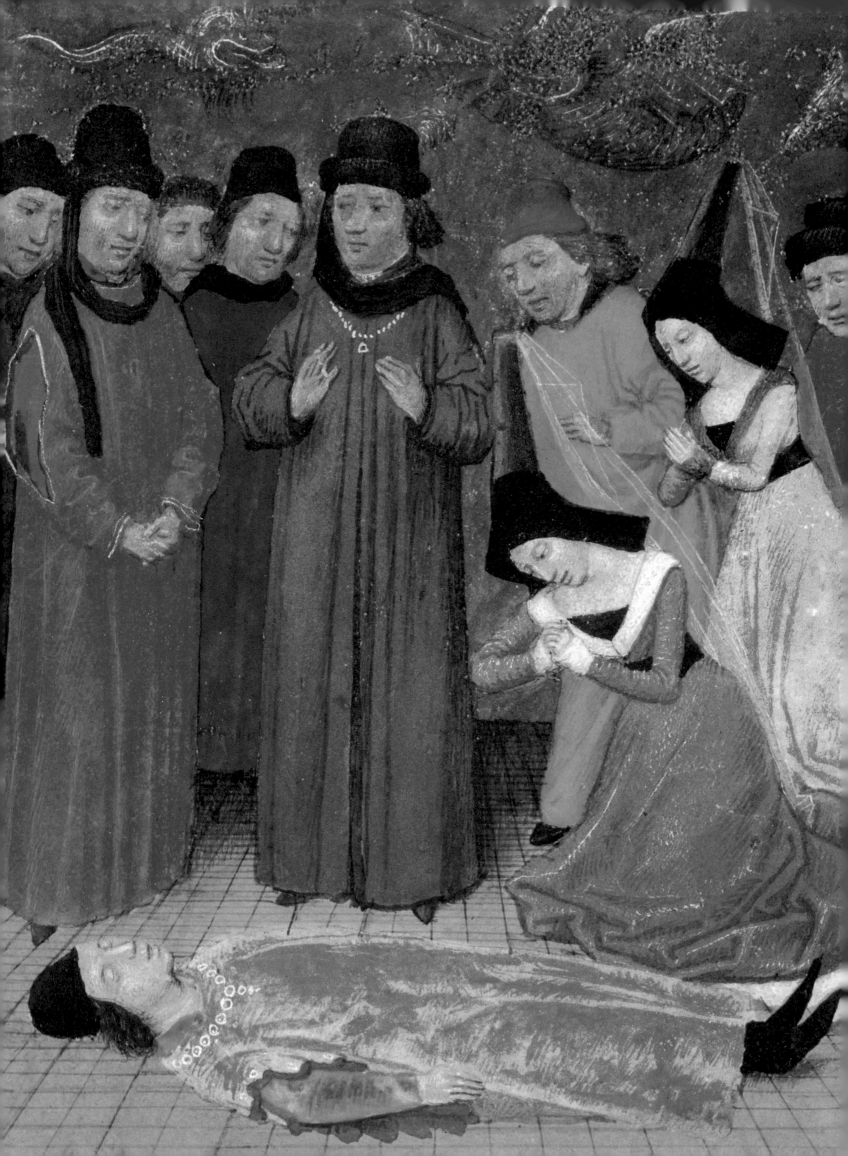

PREFACE

Les Visions du chevalier Tondal is a Burgundian illuminated manuscript in the collection of the J. Paul Getty Museum. Its text relates the story of a wealthy knight (known variously as Tondal, Tundal, or, in Latin, Tnugdal) who embarks upon a dreamlike journey through hell, purgatory, and heaven, in which he discovers the wages of sin and the value of penitence. One of the most popular narratives of the Middle Ages, *The Visions of Tondal* survives in hundreds of copies in fifteen languages; yet it was only once illuminated with a cycle of miniatures. In 1987 the J. Paul Getty Museum had the good fortune to acquire this luxurious manuscript (now Ms. 30) along with its companion volume, *The Vision of the Soul of Guy de Thurno* (Ms. 31). The miniatures in both are attributable to Simon Marmion of Valenciennes, a celebrated painter and illuminator, a number of whose finest paintings and most lavish illuminated manuscripts were represented in the collections of the dukes of Burgundy. The twenty miniatures of *The Visions of Tondal*, especially the lively representations of the torments of hell, are among the most original and compelling achievements of his career.

The history of the manuscript involves other individuals prominent at the Burgundian court. Margaret of York, Duchess of Burgundy, commissioned *The Visions of Tondal*. Her library contained the finest illuminated manuscripts made during the 1470s. David Aubert, who had been court scribe to the legendary Burgundian bibliophile Duke Philip the Good, wrote the Getty Museum's copy and signed it. Aubert's colophon indicates that the manuscript was written in Ghent, Margaret's principal residence and a major artistic center in 1474, when Aubert dated this book. The 1470s was one of the most exciting decades in the tradition of Burgundian book illumination, which experienced its greatest flowering during the fifteenth century in Flemish and northern French cities.

The aim of the following essays is to introduce *The Visions of Tondal* in the context of its time. The essays begin with a discussion of the popular medieval text of *The Visions of Tondal*, which is no longer familiar to modern audiences, and the tradition of visionary literature that lies behind it. Then the library of Margaret of York is discussed against the background of the taste and lavish patronage of the Burgundian court. The next section explores the manuscript's illumination, reviewing briefly the career of Simon Marmion and the dramatic developments in Burgundian manuscript illumination of the 1470s. Finally, all of the miniatures in *The Visions of Tondal* are reproduced in sequence. An excerpted translation of the pertinent text of the Getty manuscript, which itself was a French translation of the Latin original, accompanies each miniature. The abridged narrative of the whole story is thus available in a faithful translation.

This book is published on the occasion of the exhibition *"The Visions of Tondal" and Manuscripts from the Time of Margaret of York* at the J. Paul Getty Museum. A second exhibition at the Huntington Library in San Marino, California, features a book of hours also attributable to Marmion. All of the miniatures

Tondal Appears Dead (fol. 11)

from both books are on view. The present publication is intended to introduce Getty Museum Ms. 30 to modern audiences. It is not a catalogue of the exhibition; however, wherever pertinent, books from the exhibitions are included in the discussion. A facsimile of the manuscript with full scholarly commentary is planned for the future.

For critical reading of all or portions of the text, the authors wish to thank Maryan Ainsworth, Nigel Morgan, and John Plummer. For information and other assistance we are indebted to Jeffrey Hamburger, Ranee Katzenstein, Maximiliaan Martens, Christiane van den Bergen-Pantens, Jean-François Vilain, and the late Philip Hofer. For assistance with photographs, we are indebted to Georges Dogaer, Henning Bock, and Anne Huyghes-Despointes.

The exhibition at the Huntington Library was organized by Mary Robertson; that at the Getty Museum by Thomas Kren, with the assistance of Maximiliaan Martens and Jennifer Haley.

THE VISIONS OF TONDAL AND THE
VISIONARY TRADITION IN THE MIDDLE AGES

T he story of a medieval Irish knight whose soul takes temporary leave of his body and is led by his guardian angel on a journey through hell, purgatory, and heaven, *The Visions of Tondal* was written in the south German city of Regensburg by a monk who identifies himself in the prologue as Marcus. Also in the prologue is Marcus' dedication of his work to an abbess whom he simply refers to as "G," a woman who has been identified as Gisila, abbess of the Benedictine convent of Saint Paul's in Regensburg from about 1140 to 1160. Marcus composed his text around the time of the putative date of the vision, 1149. (To bolster the tale's credibility, Marcus relates major events of that year. The reader is informed, for example, that Tondal's visionary journey took place in the second year of the reign of King Conrad, during his Crusade; in the fourth year of the papacy of Eugene III; and in the same year as the death of Saint Malachy, Bishop of Down.) References to Irish political and ecclesiastical affairs make it clear that Marcus was an Irish monk; he was, perhaps, a visitor to the convent of Saint Paul's. That Marcus was writing specifically for the Irish community at Regensburg is revealed by his inclusion in the *Visions* of references to two Irish kings who had made donations to the monastery of Saint James in Regensburg, the mother house of Saint Paul's. At Regensburg, only the Irish would have truly appreciated the mention of two of their benefactors in Marcus' story. The author also informs his readers that the work, which he wrote in Latin, is a translation "de barbarico," by which they are to understand "from the Irish."

Of all the medieval visions describing the hereafter, *The Visions of Tondal*, before the arrival of Dante, was the most widely read. One can gauge its popularity from the large number—243—of surviving manuscripts, nearly all of which range in date from the twelfth to the fifteenth century (though a handful come from the period between the sixteenth and nineteenth centuries). Of these manuscripts, 154 are in the Latin original, and an additional fourteen in Latin, now lost, are known to have existed from medieval catalogues or later copies. The rest of the manuscripts are in vernacular translations, and, indeed, the fact that the *Visions* was so quickly translated after its creation into all the major, and many minor, European languages—German, French, Dutch, Italian, Spanish, Icelandic, and English, among others—is another testimony to the text's popularity. There are ten different translations into German, for example, found in thirty-two surviving manuscripts; ten French translations in fourteen different manuscripts; four translations each into Dutch and Italian; and even two different translations into Serbo-Croatian. The work was most widely read during the fifteenth century (over half of the surviving Latin manuscripts date from that time), and the printing press took up where the quill left off. There are thirty-four early printed editions from the late fifteenth and the early sixteenth century: twenty-two, for example, in German, five in Latin, and five in Dutch.

The Visions of Tondal was also transmitted indirectly through the writings of various theologians, chron-

iclers, and sermon compilers who, in the typical medieval fashion of appropriation, incorporated all or part of the story into their works. In the early thirteenth century, Helinand of Froidmont included the *Visions* in his *Chronicon*. Shortly after this, around the middle of the same century, Vincent of Beauvais borrowed the text of the *Visions* from Helinand for inclusion in his grand encyclopedia, the *Speculum Historiale*. Vincent's compendium was itself extremely popular in the late Middle Ages, undergoing translation into numerous languages and available in early printed editions.

The Visions of Tondal appears toward the end of a long line of accounts that chronicle supposed visits to, or visions of, the next world. In the Middle Ages, the realms inhabited by the dead (especially purgatory and hell) were, it was believed, places that physically existed and could be visited by persons specially chosen. As a reflection of man's attempt to cope with the unknown, religions throughout history have traditionally employed emissaries who travel to the next world and then come back to tell what they have seen. The most famous of all journeys to the hereafter is, of course, Dante's *Divine Comedy*, written in the early fourteenth century, about one hundred and fifty years after Marcus' account. Dante's tour through hell, purgatory, and heaven bears, at times, certain similarities to Tondal's (and, indeed, Dante is thought to have been influenced by Marcus' work). But long before *The Divine Comedy* began to cast such a large shadow over its predecessors in the visionary genre, *The Visions of Tondal* was the most widely read account of a journey to the hereafter, and in northern Europe Marcus' story continued to rival Dante's in popularity to the end of the fifteenth century. It is worth outlining a brief survey of the most influential of the visionary accounts to understand the position held within this genre by *The Visions of Tondal*. Some of the stories included in this survey, as their details will make apparent, provided Marcus with inspiration for specific features that he incorporated into his narrative.

As early as the Babylonian *Epic of Gilgamesh*, dating in part to around 2000 B.C., heroes have been said to journey to various otherworldly regions. In search of his dead companion, Eabani, Gilgamesh had to travel across the waters of death, enter into the darkness beneath a mountain, encounter threatening beasts, and find an enchanted garden and a fountain of healing powers. Among the ancient Greeks, early visitors to the other world included Ulysses, Hercules, and Orpheus. The latter descended to the underworld in search of his dead wife, Eurydice. According to the Roman poet Virgil, Aeneas wandered through an underworld topographically rich in rivers, fields, paths, walls, and woods. The *Aeneid* recounts Aeneas' horror at the torments he sees and describes the sufferings of the dead as they endure exposure, whirlpool, and fire. Virgil was one of the few pagan authors to enjoy a popularity that stretched across the entire Middle Ages, and his description of Hades was a continual influence on the medieval visionary imagination.

Reports of visits to the other world did not cease with the arrival of Christianity. Matthew and Luke in their Gospels, and Peter in his First Epistle, allude (if rather obscurely) to what was later called Christ's Harrowing of Hell. The soul of Christ, after his death on the cross and before his resurrection, was said to have left his body and descended into hell. There, he released the souls of the just who had been patiently awaiting redemption. The event, although only hinted at in what was to be accepted as the canonical Bible, was more fully described in the apocryphal Gospel of Nicodemus and in later medieval texts such as *The Golden Legend*. The theme was an extremely popular one in medieval art and traditionally showed Christ striding across the fallen doors of hell, beneath which lay the crushed figure of the

devil, and seizing the outstretched arms of Adam, Eve, and other Old Testament figures. The story of Christ's descent to hell gave a kind of legitimacy to the medieval accounts of visits to the other world.

The Christian concern with eternal salvation—and, conversely, with the dread of perpetual damnation—made the next world a more frequented place than it had been in the classical world. Beginning as early as the first or second century, there appeared increasingly numerous accounts of people who supposedly went to the next world in person or through visions. The second-century *Apocalypse of Saint Peter* offered Christians one of the earliest descriptions of the hereafter, an account the saint had received, according to the text's introduction, from Christ himself. Hell consisted of fire and darkness, beasts and worms, and heaven was a garden of trees and fruit, sweetly perfumed. Saint Paul, according to the third-century *Apocalypse of Saint Paul*, also undertook a journey to the next world. (The prologue informs the reader that the original manuscript was discovered buried in the foundation of Paul's home.) The lengthy story describes in detail many features of heaven, hell, and an intermediary zone that would later be called purgatory. Paul's account was an important one for the visionary genre, and many elements in his tale were borrowed by numerous later authors, Marcus, in his *Visions of Tondal*, being one of them. Paul, like other later visitors to the next world, had an angelic guide, heard angels castigating their charges for ignoring their counsel while alive, saw souls tortured by fire up to their navels, witnessed the reward of the faithfully married, visited the blessed seated on golden thrones, and was granted a vision of the whole earth in a single glance.

Over the following centuries, the number of accounts of visionaries and of travelers to the next world, patterned on the apocalypse of Saint Peter and especially of Saint Paul, multiplied. In his sixth-century *History of the Franks*, Gregory of Tours recounted the *Vision of Sunniulf*, in which Abbot Sunniulf saw sinners submerged in a river of fire, some to the waist, others to the chin, and a narrow bridge that spanned this flaming river. Also in the sixth century, Gregory the Great in his *Dialogues* told of visions experienced by a man named Peter, by a certain Stephen, and by an unnamed soldier. These three saw many of the features of the other world that were becoming increasingly familiar to medieval audiences: bridges over dark rivers, terrible creatures, a field of sweet flowers, men and women dressed in white, and angelic guides. Stephen was able to tell his story since, although his soul had left his body, it was able to return because his corpse had remained unburied for a night when no surgeon could be found to embalm him. The anonymous soldier, too, was on the point of death when his soul was able to take temporary leave of his body. (Like Stephen and the anonymous soldier, Tondal, too, will appear to be on the edge of death while his soul takes his tour of the next world.)

The Venerable Bede, in his *Ecclesiastical History of England* of the eighth century, included a story that clearly influenced *The Visions of Tondal*; it was known as *The Vision of Drythelm*. In the year 696, a man named Drythelm fell sick and apparently died. Led by a guide with a shining countenance, he was first taken to a huge valley, half of which was filled with fire and half with ice; the souls were tortured by being tossed from one side to the other. Proceeding through an ever-increasing darkness, he was abandoned by his guide just as they came to an abyss from which rose and fell a geyser of fire filled with souls. Devils were dragging souls into the burning pit, and they came to threaten Drythelm, but his guide returned and drove them away. The pair then proceeded to an area of light and came to a huge wall without doors. Without knowing how, Drythelm found himself on the other side of the wall, where there was a fragrant

field filled with flowers and inhabited by men and women dressed in white. These were the "good but not perfect" who waited to see Christ after the Day of Judgment. Drythelm was reluctant to return to his body, but his guide told him he must. After waking, Drythelm gave away his wealth and led a new life.

Written in the middle of the twelfth century, *The Visions of Tondal* came toward the end of this long visionary tradition. Although one of the lengthier—and more elaborate—of these tales, it was followed by another involved account, written around the end of the twelfth century: the Knight Owen's *Vision of Saint Patrick's Purgatory*, a journey that supposedly took place in 1153. (*The Visions of Tondal* and *Saint Patrick's Purgatory* are the most important contributions Ireland made to the medieval visionary genre.) Patrick's Purgatory is the name of an actual Irish pilgrimage site, famous in the Middle Ages, situated on an island in a lake called Lough Derg. On the island is a cave that Christ had revealed to Saint Patrick as one of the entrances to purgatory. The medieval pilgrim who could safely spend a night there—where he was guaranteed unpleasant experiences—would be purged of all his sins.

The culmination of this tradition of visionary accounts was, as mentioned earlier, *The Divine Comedy* of the early fourteenth century. The popularity of Dante's work is indicated by the six hundred manuscripts of the work that have come down from the fourteenth century alone; double that number survive from the fifteenth century. But while *The Divine Comedy* is the apogee of accounts of journeys to the other world, there is a fundamental difference between it and the earlier texts. Stories like *The Visions of Tondal* were written as chronicles, in a manner to convince the reader that the events described actually took place. At the time of their creation, these accounts were taken as fact. *The Divine Comedy*, however, while it might have shared with works like the *Visions* a goal of moral instruction, was never intended to convince its reader that the poet had actually made the journey he describes.

During the three hundred and fifty years of its popularity (from the mid-twelfth to the early sixteenth century), *The Visions of Tondal* enjoyed a wide readership. Its original audience, which could understand Latin, was the monastic community. But the early and numerous translations into the vernacular are an indication of its ever-increasing and less-cloistered audience. The readership of the *Visions* first expanded in the area where it was produced, in southern Germany and Austria. By the fifteenth century, the *Visions* was still being read in Latin but more frequently in the vernacular, in France, England, and, even more so, in northern Germany and the Netherlands. By the late Middle Ages, its readers included preachers and priests, members of the Tertiary Orders (lay members of religious orders), and the laity. (The last group was the smallest, but, significantly, it included Margaret of York, who commissioned the copy of the work now in the Getty Museum.) *The Visions of Tondal* provided an instructive and practical treatise on subjects that dominated the genuinely pessimistic spirituality of the late Middle Ages: Death, Judgment, Heaven, and Hell (the so-called "Four Last Things"). The *Visions* was often one of several devotional texts—dealing with pilgrimages to the hereafter or a range of visions—that were frequently bound up together as a single book. This may have been the case, for example, with Margaret of York's copy of *The Visions of Tondal*, which has, as a sister volume, *The Vision of the Soul of Guy de Thurno*, a tale about a man who comes back from purgatory to haunt his wife. The two books were at one time bound together. Read by the pious, these stories encouraged the performance of penance in this world so as to avoid greater tribulations in the next. The *Visions* remained one of the most popular of these accounts, not

only because of its content but also because of its style. Before *The Divine Comedy*, it contained the most detailed description of the hereafter. It also featured a fast pace, lively dialogue, and one of the more sympathetic central characters in visionary literature. Unlike the majority of medieval visitors to the next world, Tondal is neither a monk nor a saint but a worldly knight. The medieval reader, no matter how sinful, could identify with him. This realistic characterization made *The Visions of Tondal* still worth reading after it had ceased to be perceived as a factual account and had begun to be enjoyed as an inspirational tale.

Roger S. Wieck

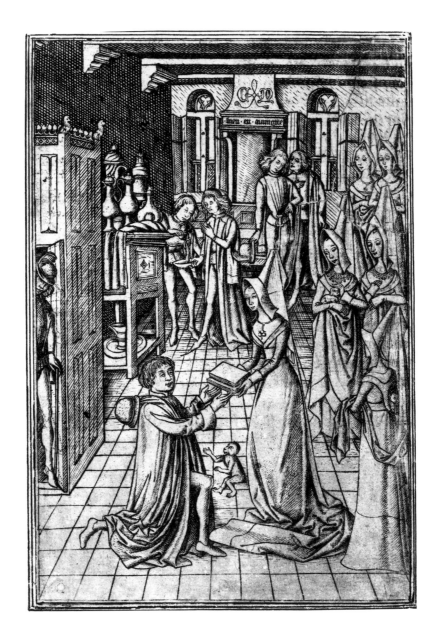

FIGURE 1. *Caxton Presenting His Translation to Margaret of York.*
Engraved frontispiece to Raoul Lefèvre, *The Recuyell of the His-*
toryes of Troye, Bruges, circa 1475. San Marino, California, The
Huntington Library.

THE LIBRARY OF MARGARET OF YORK
AND THE BURGUNDIAN COURT

". . . the visions of a knight called Tondal written by command of the very exalted, most excellent,
and very powerful princess Madame Margaret of York by the grace of God Duchess of Burgundy,
of Lorraine, of Brabant, of Limbourg, of Luxembourg, and of Guelders. Countess of Flanders, of
Artois, of Burgundy. Palatine of Hainaut, of Holland, and of Zeeland, of Namur, and of Zutphen.
Marchioness of the Holy Roman Empire. Dame of Salins and of Malines . . ."

Margaret of York, the Duchess of Burgundy, commissioned *The Visions of Tondal*: the colophon at the end of the text identifies her as the book's patron. A bibliophile of great taste and discrimination, Margaret commissioned or acquired for her small library a number of the most beautiful Flemish illuminated manuscripts made during the 1470s. This decade saw not only the production of some of the finest of all Burgundian manuscripts, but the emergence of a new aesthetic in the art of illumination in the Burgundian Low Countries. Between 1468, the year of her marriage, and 1477, when her husband, Charles, died, the duchess enjoyed the services of the finest illuminators, scribes, and printers of the day (fig. 1). Through her marriage, she had joined a Burgundian tradition of artistic patronage and bibliophily that had few rivals throughout Europe.

As Duchess of Burgundy, Margaret was one of the most powerful women of her time. The colophon of *The Visions of Tondal* records her titles and possessions in the year 1474 (fig. 2). Her Burgundian territories extended north of Amsterdam and as far south as Mâcon in French Burgundy (fig. 3). To the west they reached the coast, along the North Sea and the English Channel, while to the east they included Luxembourg and Nancy and reached sections of the Mosel River. The rapid growth and expansion of Burgundy in the fifteenth century, through the attachment of one feudal domain after another, transformed the small duchy in the center of France into one of the major powers of Europe. Charles' father, Duke Philip the Good, who ruled from 1419 to 1467 and was largely responsible for Burgundy's expansion (see fig. 4), moved his court north from French Burgundy among the towns of modern-day Belgium and northern France: Bruges, Ghent, and Lille.

The magnificence of the Burgundian court represented a supreme expression of medieval chivalric ideals. Philip the Good envisioned his role as that of the ideal Christian knight and commissioned art to promote this image. Pageantry, ritual, and multifaceted artistic creations were vehicles to express the mythology of Philip's character as knight and ruler of vast domains. Prominent subjects among the tapestries, manuscripts, and other lavish works of art that he commissioned are such heroes of antiquity as Alexander the Great and Hercules and beloved rulers of the early Middle Ages such as Clovis and Girart de Roussillon (fig. 5). Court art presented these men and classical deities as the glorious predecessors of the duke. Philip used art on a vast scale to fashion his public persona and heighten his prestige.

In keeping with Philip's flair for chivalric image-making, the most popular subjects in his library, as

FIGURE 2. Colophon of *The Visions of Tondal*. Malibu, J. Paul Getty Museum, Ms. 30, from fols. 43v–44.

well as some of the most splendid books, are histories and other tales of his vaunted spiritual forebears. He commissioned numerous lavishly illustrated tomes such as the four-volume *Histoire de Charles Martel* (now in the Bibliothèque Royale in Brussels), a chronicle of the Carolingian dynasty that contains over one hundred miniatures. (By the nineteenth century a number of leaves had been removed from this manuscript, and fifteen are now in the collection of the Getty Museum.) The *Histoire de Charles Martel* prominently features one of Philip's particular heroes, Girart de Roussillon (fig. 5), whose political circumstances as a vassal of the French king Charles the Bald called to Philip's mind his feudal obligations to the French king Charles VII. Philip hated the French ruler, who had killed his father, just as Girart repeatedly did battle with his treacherous French lord.

Philip was the most enlightened patron of northern Europe. Among the celebrated artists in the duke's employ was the greatest Flemish painter of the fifteenth century, Jan van Eyck of Bruges. Van Eyck served the duke for most of his career, from 1425 until his death in 1441. Philip was patron to painters, weavers, gold- and other metalsmiths, as well as scribes and illuminators. He also commissioned music and literature. Philip's love of beautiful books nourished the flowering of manuscript illumination in the Burgundian Low Countries during the middle of the fifteenth century. A wide circle of courtiers, following his example, contributed through their patronage to the extraordinary efflorescence of the illuminator's art.

The fifteenth century saw the building of some of the great secular libraries not only in Burgundy but throughout Europe. The library of Philip the Good was one of the finest of all. Its holdings were not only extensive and varied—Philip owned as many as a thousand books—but its manuscripts were richly dec-

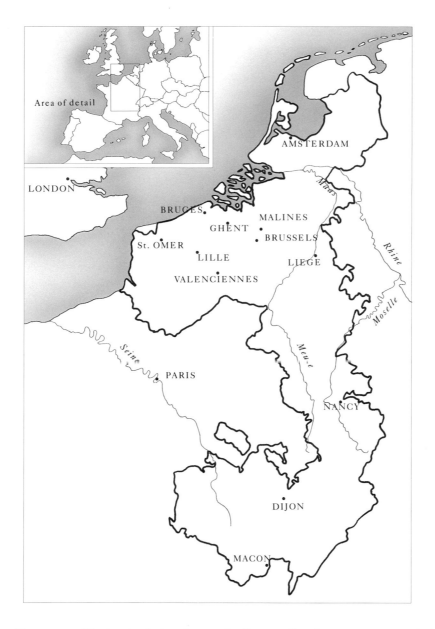

FIGURE 3. Territories belonging to the Burgundian dynasty up to 1476, including bishoprics under Burgundian influence.

orated. Under Philip's patronage, the art of illumination flourished in Brussels, Bruges, Ghent, and other Burgundian towns in the economically prosperous Low Countries.

Philip collected finely illuminated books of all kinds. His library included medieval and classical literature, ancient history, didactic and theological writings, lives of the saints, and biblical and liturgical texts. About a quarter of his library was inherited. Other books were commissioned, many were purchased, and some were received as gifts. One of the most spectacular belongs to this last category, a large, sumptuous *Grandes Chroniques de France* now in Leningrad, its miniatures attributable to Simon Marmion. The book was presented to Philip in the late 1450s by Guillaume Fillastre, Abbot of Saint Bertin and Bishop of Toul (and later Tournai). Among the illuminators whom Philip himself employed were Marmion, Loyset Liédet, Dreux Jean, Willem Vrelant, and Jean le Tavernier. Philip not only commissioned books to be written and decorated, but he also ordered the translation of numerous texts into

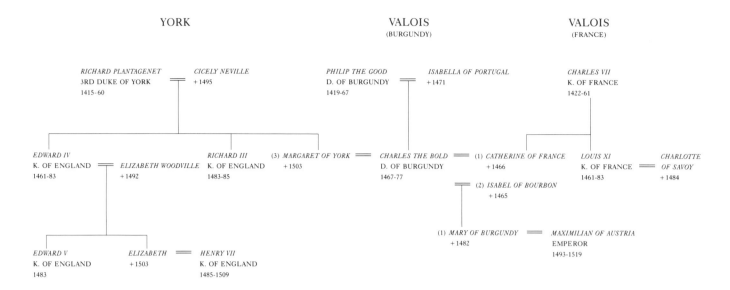

YORK VALOIS (BURGUNDY) VALOIS (FRANCE)

RICHARD PLANTAGENET
3RD DUKE OF YORK
1415-60 ══ CICELY NEVILLE +1495

PHILIP THE GOOD
D. OF BURGUNDY
1419-67 ══ ISABELLA OF PORTUGAL +1471

CHARLES VII
K. OF FRANCE
1422-61

EDWARD IV
K. OF ENGLAND
1461-83 ══ ELIZABETH WOODVILLE +1492

RICHARD III
K. OF ENGLAND
1483-85

(3) MARGARET OF YORK +1503 ══ CHARLES THE BOLD
D. OF BURGUNDY
1467-77 ══ (1) CATHERINE OF FRANCE +1466

LOUIS XI
K. OF FRANCE
1461-83 ══ CHARLOTTE OF SAVOY +1484

(2) ISABEL OF BOURBON +1465

EDWARD V
K. OF ENGLAND
1483

ELIZABETH +1503 ══ HENRY VII
K. OF ENGLAND
1485-1509

(1) MARY OF BURGUNDY +1482 ══ MAXIMILIAN OF AUSTRIA
EMPEROR
1493-1519

FIGURE 4. Genealogical table of the families of Charles the Bold and Margaret of York.

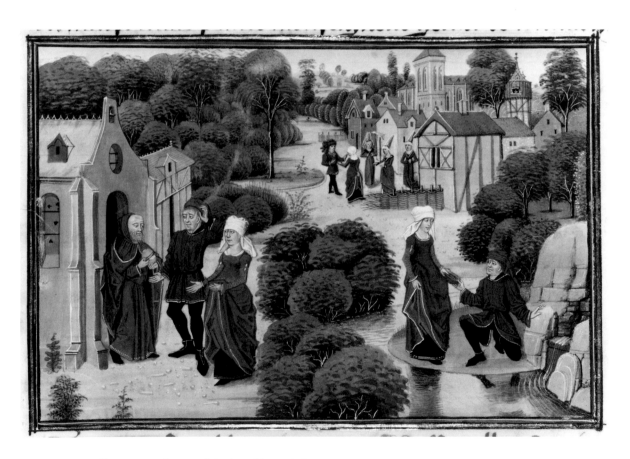

FIGURE 5. Loyset Liédet, *Girart de Roussillon and Bertha Find Sustenance at the Hermitage.* Cutting from *Histoire de Charles Martel,* 1470–1472. Malibu, J. Paul Getty Museum, Ms. Ludwig XIII 6, no. 5.

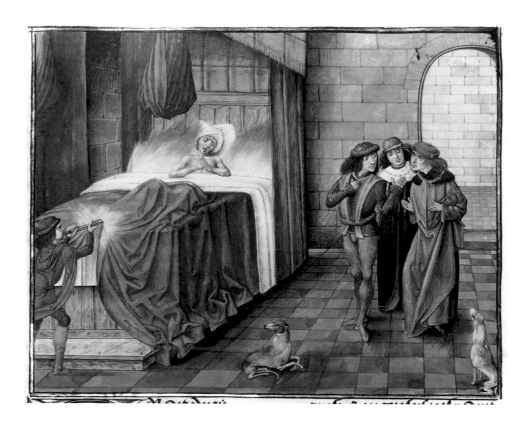

FIGURE 6. The Master of the White Inscriptions, *The Immolation of Charles II, King of Navarre*. Jean Froissart, *Chroniques*, book 3, circa 1480–1483. Malibu, J. Paul Getty Museum, Ms. Ludwig XIII 7, fol. 274v.

French from Latin. Jean Wauquelin, Jean Miélot, and David Aubert served as scribes, editors, and translators of his texts. Aubert's encomium to his patron Philip proclaims his achievement: "He was the prince of Christianity; without reservation [one can say] that no one was better furnished with a rich and authentic library." Philip's appetite for illuminated manuscripts continued unabated until the end of his life. At his death, about seventeen manuscripts that he had commissioned were left unfinished.

The significance of this Burgundian bibliophily for modern libraries is great. The majority of Philip's 350 surviving books are among the original collections of the Belgian national library, the Bibliothèque Royale in Brussels, which was founded in 1559. Philip's love of books led not only his son Charles and his daughter-in-law Margaret to form libraries, as we shall see, but it also encouraged Margaret's brother King Edward IV of England to start a library. Edward's books became part of the English royal library, much of which today belongs to the British Library in London. One of the lavish Burgundian volumes that Edward probably purchased for his library is the Getty Museum's copy of Froissart's *Chroniques* (see fig. 6).

Philip's heir, Charles, who became duke in 1467, was more intensely involved than his father in military affairs. His dreams of conquest were fueled by tales of his father's heroes, such as Alexander the Great and Girart de Roussillon. But he also loved court pageantry and ceremony. Undoubtedly to rival the opulence of his father's court and to proclaim the continued magnificence of the Burgundian dynasty, Charles arranged for his wedding to Margaret of York to be a celebration more extravagant and ostentatious than any other in the fifteenth century. As a result, Margaret's introduction to Burgundian taste and

the court's love of luxury was the grandest imaginable. The finest artists from all over the realm were engaged to create the decorations and displays: the painters Jacques Daret from Tournai and Hugo van der Goes from Ghent, and dozens of other sculptors, metalsmiths, and craftsmen of precious jewels. Margaret's entry into Bruges, *tableaux vivants*, fireworks, tournaments, musical presentations, and banquets with diverse entertainments were staged over nine days in a continuous sequence of festivities. One observer of the wedding celebration compared the ducal court to King Arthur's, and writers proclaimed its wonders for decades afterward.

Charles developed a taste for books when he was still Count of Charolais. Following his father's death he had Philip's unfinished books completed, a task that involved commissioning hundreds of miniatures. He also favored books about the great conquerors and commissioned a new translation of the life of Alexander the Great that became extremely popular (see fig. 7). He loved classical texts, especially those dealing with the education and responsibilities of rulers. These choices reflect his own deep commitment to governing as well as his dreams of conquest. In this connection, Charles introduced a new category of deluxe illuminated manuscript, the ordinance book. These slim volumes contained regulations on diverse matters: the ducal household, military affairs, livery, and taxes. Widely influential in the next century, they reflect Charles' desire to regulate military affairs and the business of his court more rigorously.

The scribe Nicolas Spierinc, who wrote some of the most beautiful of Charles' ordinance books, also wrote for Charles a prayer book now in the Getty Museum (see fig. 8). Spierinc's calligraphy was the most elegant and inventive of its day. The prayer book's illumination by Liévin van Lathem and its ambitious script offer ample evidence that Charles had inherited his father's sophisticated artistic taste.

Aside from these books, however, the finest illuminated manuscripts of Charles' era were commissioned by his wife, Margaret of York. Margaret, the daughter of Richard, the Duke of York, and Cicely Neville, lived much of her life in the midst of political strife (see fig. 4). Her brother Edward IV gained the English throne on the battlefield in 1461 and died at the age of forty-one in 1483. Shortly thereafter, the throne was usurped by another brother, Richard III, who was killed two years later. Her husband Charles' continuous involvement in military affairs resulted in his premature death: he fell at the Battle of Nancy in 1477, nine years after their marriage. The widowed Margaret was left to look after the heiress to the Burgundian domains, twenty-year-old Mary of Burgundy, Charles' daughter by his second wife, Isabel of Bourbon.

Civil unrest, political intrigue, and warfare continued in the Burgundian domains for seventeen years. Mary died in 1482 in a riding accident, and her widower, the Habsburg archduke Maximilian of Austria, devoted his energies to bringing the newly acquired Netherlandish territories under his control. The dowager maintained a close relationship with him in this period, and Margaret's court at Malines was frequently one of the few havens of stability within the realm. She also assisted in ill-fated attempts to restore the House of York to the English throne following her brother Richard's death. For a quarter of a century, she was at the center of political events that shaped European history. She never remarried, and died in 1503 at the age of fifty-seven.

Margaret's small library is both historically and artistically important. Her books—nearly all commissioned while her husband, Charles, was still alive—deal with devotional and theological matters. They comprise collections of treatises, along with the writings of the Church fathers and the venerated authorities of the Church: Saint Augustine, Saint Bernard, and Saint John Chrysostom; writings prescrib-

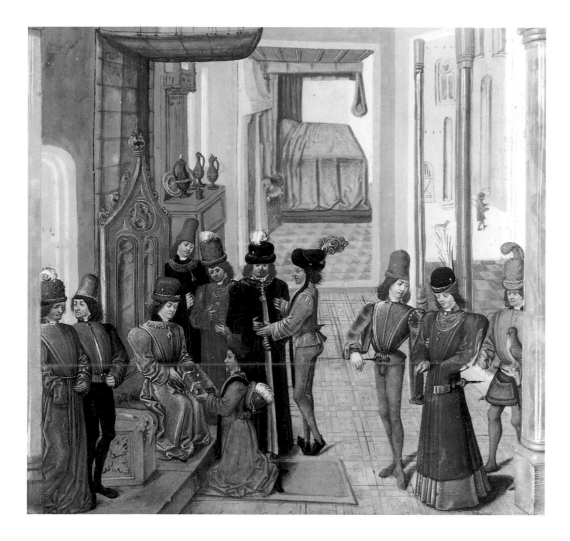

FIGURE 7. The Master of Margaret of York, *Vasco da Lucena Presents His Trans-lation to Charles the Bold* (detail). *Livre des fais d'Alexandre le grant*, late 1470s. Malibu, J. Paul Getty Museum, Ms. Ludwig XV 8, fol. 2v.

ing devotional practices by such eminent theologians as Jean Gerson; and other, often anonymous writ-ings, such as treatises on charity, on confession, on preparation for death, on the vanity of the world. Her library included visionary literature, in which revelation of the meaning of repentance and redemption comes through mystical experience. Although many of these texts are read today only by specialists, in the Middle Ages some, such as *The Visions of Tondal*, were the equivalents of modern-day best-sellers. Margaret's visionary texts include the Getty Museum's *Visions of Tondal* and *The Vision of the Soul of Guy de Thurno*, the Pierpont Morgan Library's *Apocalypse*, and *Saint Patrick's Purgatory*, now in the Biblio-thèque Royale in Brussels. Taken together, Margaret's books form a focused selection and suggest her great personal piety and her concern with devotion.

Devotional books, such as prayer books and books of hours, which provide readings for private prayer throughout the day, were common to all late medieval libraries, and these and other religious books were the primary illuminated manuscripts that noblewomen were likely to acquire. For several centuries be-fore Margaret's era, women of the nobility were responsible for commissioning illuminated devotional texts of great splendor. Around the year 1200, Queen Ingeborg of France commissioned the celebrated

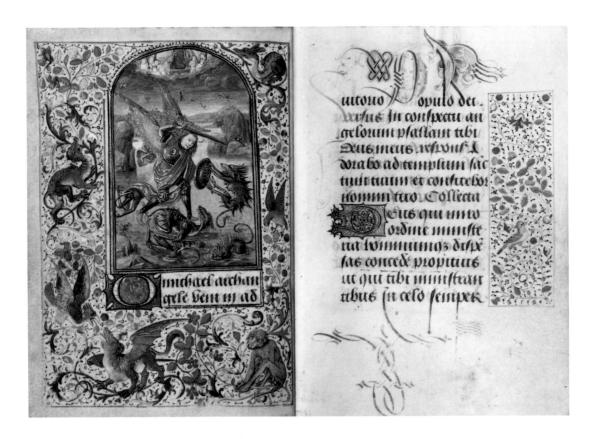

FIGURE 8. Liévin van Lathem, *Saint Michael and the Dragons*. Prayer Book of Charles the Bold, written by Nicolas Spierinc, 1469. Malibu, J. Paul Getty Museum, Ms. 37, fols. 15v–16.

psalter that is named after her (Chantilly, Musée Condé). Jeanne d'Evreux, Jeanne of Savoy, and Bonne of Luxembourg owe their places in history in part to the splendid books of hours that they commissioned; Mahaut d'Artois commissioned still other illuminated religious and secular texts. In the fifteenth century, Charlotte of Savoy, the wife of the French king Louis XI, owned a sophisticated library with numerous prayer books, devotional treatises, and other religious texts, along with a range of romances and secular subjects. She acquired, probably more by inheritance than commission, over one hundred books; some were illuminated. Margaret of York's library, of which we know only about twenty titles, consisted nearly entirely of books commissioned or acquired during her years as duchess. It is a collection of richly illuminated manuscripts that concern spiritual development even more than daily devotional practice. Its most beautiful books are not simply the traditional books of hours, psalters, and prayer books, but are volumes that reflect the theological and philosophical concerns of the devout.

Margaret's piety was inspired in part by her own background and circumstances. Her mother, Cicely, the Duchess of York, who lived to be eighty, was herself an individual of great piety and highly disciplined religious practice. Cicely had a library of religious books, including devotional treatises and mystical writings by a number of women saints, which enjoyed widespread popularity in the late Middle Ages. However, none of these books survives, and it is unlikely that they were as finely or richly illuminated as the best of her daughter's manuscripts. Moreover, Margaret's husband, Charles, was also deeply devout and faithfully attended religious services. Margaret herself was by no means modest in

proclaiming her piety: among the most beautiful miniatures and frequent subjects in her books are those that represent her in prayer. Indeed, in the frontispiece to *Blessed Are the Merciful* (*Benois seront les miséricordieux*), a selection of devotional writings now in the Bibliothèque Royale in Brussels, Margaret appears performing each of the charitable deeds called the Seven Acts of Mercy (fig. 9).

Spiritual movements of the fifteenth century promoted reform within the Church, a cause that Margaret pursued throughout her years with Charles and subsequently as dowager. Just as her mother read fervently the writings of monastic saints, Margaret became involved in the establishment and reform of convents and monasteries throughout the Low Countries, often in the face of vigorous opposition from the local nobility. Both Margaret and Mary of Burgundy were devoted to the cult of Saint Colette of Corbie, who during the early fifteenth century had worked to reform religious orders in northern France. Margaret commissioned a *Life of Saint Colette* that was donated to the convent of the Poor Clares in Ghent before 1477. In the minds of Cicely and Margaret, their faith, combined with a sense of the responsibility of their social rank, encouraged their generosity toward the Church and toward those less fortunate. Margaret gave generously to convents and monasteries, establishing a number of new houses in England and the Low Countries. She donated finely crafted devotional objects to churches and established a scholarship at the University of Louvain for theological students, one of whom was the future Pope Adrian VI, a reforming pope.

Less is known about other aspects of Margaret's patronage, but she commissioned one painting that is attributable to Simon Marmion (a *Lamentation* now in the Metropolitan Museum) and probably a *Deposition* by a Flemish artist (now in the Getty Museum). She also played a role in the making of the first book printed in the English language. Margaret supported William Caxton, a young Englishman living in Bruges, in his endeavor to translate into English one of the most beloved texts of the Burgundian court. Raoul Lefèvre's *Recueil des histoires de Troye*, which was written originally for Philip, concerns the adventures of Hercules and the founding of the Burgundian dynasty. By 1475, Caxton had set in type his translation of Lefèvre's text, now entitled *The Recuyell of the Historyes of Troye*. Although the technique for printing books from movable type had developed in northern Europe a few decades earlier, neither Philip nor Charles seems to have owned a printed book; Margaret was the first at the Burgundian court to possess one. An engraving showing Caxton presenting this historic book to Margaret survives in a copy now in the Huntington Library (fig. 1).

Margaret took full advantage of the extraordinary artistic and scribal talents available to the court. For example, David Aubert was in Philip's service and wrote, edited, and/or translated for him at least ten substantial books between 1458 and 1467. Aubert moved to Ghent after the duke's death, and there, between the years 1474 and 1477, he wrote half a dozen of Margaret's most splendid books. Aubert's calligraphy in *The Visions of Tondal* epitomizes the elegant and refined style of formal writing at the court. One of the finest scripts of the fifteenth century, it is called today Burgundian Gothic cursive or Burgundian *bâtarde*.

Documents tell us that the Simon Marmion to whom the miniatures of *The Visions of Tondal* are attributed had earlier worked for Philip and subsequently for Charles. Duke Philip's *Grandes Chroniques de France*; the lavish, now-lost breviary he subsequently commissioned; and Margaret's *Visions of Tondal* all rank with this artist's most ambitious and distinctive commissions; the *Lamentation* executed for Charles and Margaret is one of the finest paintings in his style. Clearly the court library and the example of court

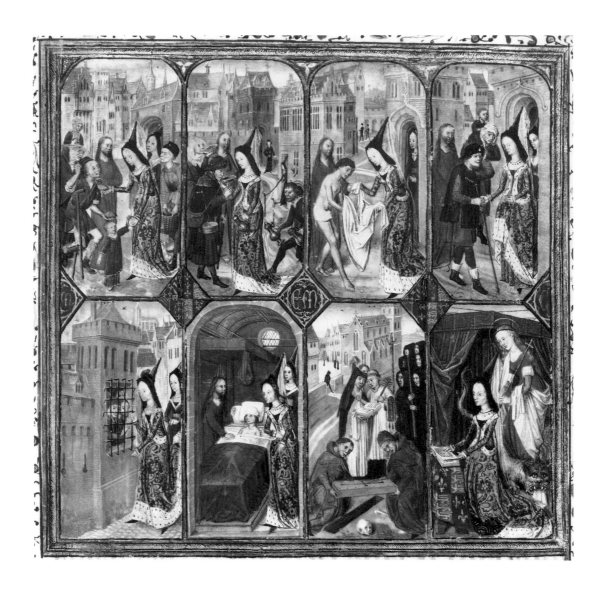

FIGURE 9. Dreux Jean or follower, *Margaret of York Performing the Seven Acts of Mercy and in Prayer*. Frontispiece to *Benois seront les miséricordieux*, circa 1470. Brussels, Bibliothèque Royale, Ms. 9296, fol. 1.

patronage helped to form Margaret's taste. She provided major artists and scribes with exciting commissions that suited her personality and reflected her noble station. *The Visions of Tondal* is notable among these works, not only for its exotic imagery but also because it is the only known illuminated copy of this text. But Margaret also employed a number of exceptionally gifted younger artists, such as the Master of Mary of Burgundy, and helped some of them launch their careers. These younger artists transformed the character of Flemish illumination, producing some of the most colorful and sumptuous manuscripts in the history of the book. Thus, Margaret's generous commissions helped sponsor the achievements of one of the most exciting decades of Burgundian illumination. The scale of her patronage was more modest than that of her illustrious Burgundian relatives, but her role was important nonetheless, for her taste and judgment helped shape the future of book illumination in the southern Low Countries.

Thomas Kren

THE VISIONS OF TONDAL, THE ART OF SIMON MARMION, AND BURGUNDIAN ILLUMINATION OF THE 1470S

I n one of the finest miniatures of *The Visions of Tondal*, damned souls burn in the mouth of the beast Acheron (pl. 7; cover). The living furnace seems to glow, red-hot, on the page. Flames lick the monster's lips in hues of red, yellow, and blue. The Getty manuscript's miniatures of hell capture the intensity of smoldering flames, their transparency, their mutability, and the spectrum of their colors. When Tondal and his guardian angel come upon the burning house of Phristinus (pl. 9), the roaring flames lick the upper arch of the opening much as they would do in a well-stoked brick oven. This is not accidental: the truth of the artist's depiction of hellfire is derived in significant measure from his close observation of everyday reality. Light from the glowing structure picks out of the darkness the monsters that hover at the edge of the opening (cf. pls. 7 and 9), all of them captured in the rich and varied hues that the naked eye perceives when staring directly into a flame. The illuminator has represented not only the color and movement but also the texture of shapeless, mutable substances.

The imaginative text of *The Visions of Tondal* challenged the artist who would illustrate it to represent not only diverse forms of hellfire but also a dark and smoky underworld, icy lakes and bitter cold, an army of infernal monsters, and the splendors of paradise: worlds entirely imagined and unseen by mortal men. The artist has married the text's evocative imagery with an acute observation of natural phenomena, mastering the representation of light, atmosphere, and continuously changing forms.

In another scene, Tondal's guardian angel shows the soul of the knight a burning valley where the souls of murderers are cooked on an iron lid (pl. 4). The fire has its own vibrancy, while smoke rises from it in veils of blue and gray. Slivers of lime green are refracted in the gaseous mist. The text itself does not mention this smoky substance, but throughout the miniatures of hell the illuminator returns again and again to the depiction of the incorporeal and to dramatic, sometimes surprising light effects: the fires rage inside the blackness of the inferno. These scenes mingle the terrible and the sublime. In the miniature of the burning valley the slim, naked souls rise and fall in a graceful ballet of torment. In yet another miniature in which the soul of Tondal witnesses the punishment of heretics and unbelievers, other souls are passed back and forth between a mountain of fire and a desolate lake of ice (pl. 5). Isolated fires leap up through the crags of a rocky, forbidding landscape, while below, in contrast, the iciness of the lake is suggested by a cool, dark, still blue. This is perhaps the eeriest of the hellscapes in *The Visions of Tondal*. Here, too, the artist has found something strange and beautiful in the horrible and the grotesque.

Color also enhances the drama of the storytelling in other sections of the manuscript. After proceeding through nearly a dozen episodes of infernal punishment on the path through hell, the guardian angel leads Tondal's soul to a domain where souls perform various types of penance before they may enter paradise (pl. 14). For this hopeful sphere, the illuminator employs an entirely new range of colors, including pastels and delicately modulated tones: soft greens, grays, violet, and the shining gold of the sky. The eye is caught by surprise: no trace remains of the gloomy browns, blacks, icy blues, or incendiary reds.

When the soul of Tondal hears the music of heaven (pl. 19), the selection of salmon, light blue, white, violet, bright green, and gold achieves a color harmony appropriate to the lyrical theme.

Although these scenes and those of paradise may seem anticlimactic or staid in relation to the tumultuous, visually intense episodes of hell, they contain a gracefulness and sweetness in the figures (see pl. 14), a simplicity in the design and rendering of landscape, and a nuance in color (see pl. 17), qualities which create an appropriately dramatic contrast with the world of the damned. The astuteness of observation of the visible world is most evident in the landscape settings, where depth of space is conveyed not only through the diminution in the size of trees and other landscape elements but also through the modulation of value and hue (pl. 14). In the representations of hell, the artist achieved something as evocative as his textual source, yet more poetic, depicting another world by carefully observing our own. In this use of naturalism, the illuminator represents the most advanced artistic concerns of his time. In the use of color, he ranks with the most original Burgundian artists.

As noted in the preface, the miniatures of *The Visions of Tondal* are attributed to Simon Marmion. Yet illuminators seldom signed the manuscripts that they painted. Indeed, the colophon of a manuscript, written at the end of a book by its scribe, provides essential information about the manuscript's production but rarely the name of the artist. As we have seen, the colophon identifies the book; the scribe, David Aubert; and the patron, Margaret of York. It also gives the place and the date when the writing was completed, namely, Ghent in March of 1474. Identifying the illuminator presents a problem, though. Lacking a signature or a mention of the artist in the colophon, we can determine an artist's identity only if the work is otherwise documented, by a record of payment, for example, or by comparison with such a documented work. Documents of this type are exceedingly rare.

Scholars have generally recognized that the *Tondal* miniatures closely resemble a group of illuminated manuscripts executed as early as the mid-fifteenth century and as late as the 1480s in the Burgundian territories of the Low Countries and northern France. However, none is signed by the artist. On largely circumstantial evidence, these manuscripts, along with a few paintings, have been attributed to the northern French artist Simon Marmion and his workshop. This essay will discuss what is known about Marmion and the relationship between the miniatures of *The Visions of Tondal* and other major illuminated manuscripts and paintings attributed to him. It will also consider the position of *The Visions of Tondal* in the context of Burgundian manuscript illumination of the time.

Praised not long after his death by the poet Jean Lemaire de Belges as the "prince of illumination," Simon Marmion served the Burgundian ducal family over several decades: the legendary bibliophile and art patron Philip the Good, Duke of Burgundy; his son Charles the Bold, the next duke; the latter's third wife, Margaret of York; and various family members and ducal courtiers. A great deal of Simon's artistic activity is documented. In 1454, Philip summoned him from his home in Amiens to help, along with thirty-four other artists, in preparing scenery and other decorations for the entertainments staged during the Feast of the Pheasant, an extravagant banquet at which Philip announced plans for a new crusade and encouraged his court to take vows to join him. Unfortunately none of these decorations survive, nor does the lavish breviary with ninety-five miniatures that the duke commissioned from Marmion in 1467. Philip died that year, and the breviary was completed three years later for his heir, Charles. Still other documents survive describing commissions to this artist for paintings as well as illumination.

The archives reveal that Marmion came from a family of artists. He was the son of the painter and

sculptor Jean Marmion. His brother Miles (Mille) was established as a painter in Tournai, where Simon himself joined the painters' guild in 1467. A Marie Marmionne, who was Simon's sister, daughter, or niece, gained a reputation as an accomplished painter or illuminator; she was mentioned by the same Jean Lemaire de Belges who extolled Marmion's qualities as an artist. By 1458 Simon had bought a house in Valenciennes, where he probably lived until his death in 1489. Despite this wealth of information about the life of Simon Marmion, we lack a single painting or manuscript that can be firmly connected to him by a document or a signature. Nevertheless, a body of circumstantial evidence supports associating Simon Marmion with the highly original and distinctive style of *The Visions of Tondal*, certainly one of the masterpieces in this style of illumination.

In the course of a career that spanned four decades, Marmion and his workshop probably produced several dozen illuminated books of hours, as well as other illuminations for a variety of texts in addition to altarpieces, portraits, and decorations for court festivities. His manuscript commissions entailed the creation of hundreds of miniatures—witness the breviary begun for Philip that called for ninety-five. Not surprisingly, therefore, several hands were responsible for executing the hundreds of miniatures and paintings linked to the name Simon Marmion. We do not know the identity of these collaborators, but there were several of them and they may have come and gone over many years. What is clear, however, is that, despite these collaborations, within the significant body of paintings and manuscripts attributed to Marmion, the numerous and extraordinary artistic inventions that have come down to us are ultimately and primarily the responsibility of a single individual.

How have scholars linked works ascribed to this complex illuminator? What are the hallmarks of his style? The most striking characteristic of the several dozen illuminated manuscripts and paintings that are associated with the name of Marmion is, in a word, naturalism. Marmion was especially gifted in the representation of light and texture, and his understanding of atmospheric effects and spatial illusion grew throughout his career. In the miniatures of hell in *The Visions of Tondal*, fire and darkness, among the most difficult artistic subjects drawn from nature, are represented with particular sensitivity and conviction. Marmion's depictions of trees, distant horizons, and air developed steadily in their sophistication over the course of four decades. As we shall see, the naturalistic quality in his work as an illuminator was enhanced by his activity as a panel painter.

Another prominent characteristic of Marmion's art is his skill as a storyteller. Marmion's miniatures display an engaging psychological content. In the dramatic opening miniature of *The Visions of Tondal* (pl. 1), the artist depicts a climactic moment: when Tondal begins to have a seizure. One hand stretched out toward the meal, he reaches to his chest with the other. As he grimaces in discomfort, the other characters turn toward him. Their responses are conveyed by a glance, a gesture, a facial expression, or a movement. The sensitivity to the inner thoughts of the characters and the ability to capture momentary action—seen also in the miniatures of hell—are two other aspects of the artist's naturalism.

Certain facial types and features are hallmarks of Marmion's style: an oval face, high cheekbones, thick eyelashes, a long, broad nose, and a distinctive low arch to the brow. One of its most original features, increasingly predominant during the last two decades of his career, is a particular choice of colors, including salmons, soft blues, violets, and brilliant greens, that sets his work safely apart from that of his contemporaries. These hues, for example, are found in the miniature of *The Glory of Good Monks and Nuns* (pl. 19). The illuminator's gift as a colorist is evident in the range of effects throughout the manuscript,

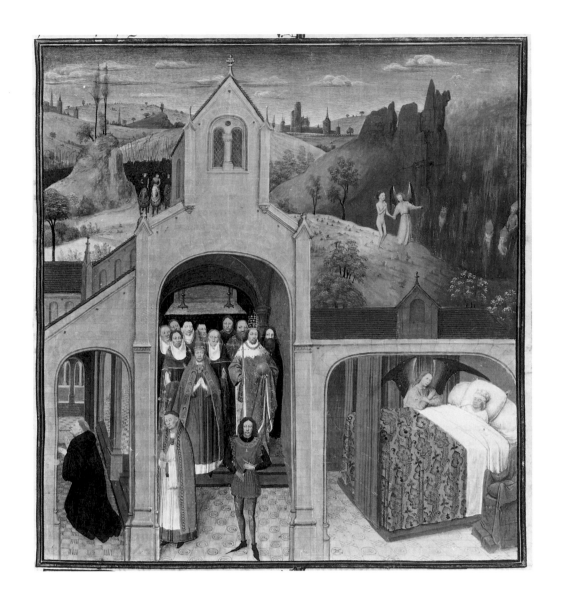

FIGURE 10. Attributed to Simon Marmion, *Emperor Lothar's Entry into the Convent of Prum*. *La fleur des histoires*, vol. 2, circa 1450. Brussels, Bibliothèque Royale, Ms. 9232, fol. 351.

from the harmony of blond hues that characterize this miniature to the glow of reds in the darkness of hell. These color choices are among the most distinctive of the second half of the fifteenth century.

Simon Marmion's talent as a narrative artist is already apparent in one of his earliest surviving manuscripts, *La fleur des histoires*, circa 1450, compiled by Jean Mansel, a member of the duke's household (see fig. 10). The text is a history of the world from the Creation, and this copy eventually belonged to Philip the Good. Similar in format to the *Tondal* manuscript, it offered the artist an opportunity to work on a relatively large scale; it also presented him with unusual and highly individual subjects. Here Marmion conveys psychological drama similar to what one will see later in *The Visions of Tondal*. In one miniature, the eyes of the Emperor Lothar, priests, and other attendees focus on the pope as he stands before the altar (fig. 11), just as, in the miniature of Tondal at dinner, all eyes focus on the knight when he becomes ill (pl. 1). In both scenes the artist persuasively conveys psychological engagement by the tilt of a head as well as a gaze. (The narrower faces in *La fleur des histoires* reflect the twenty to twenty-five years by

FIGURE 11. Detail of figure 10.

FIGURE 12. Detail of figure 10.

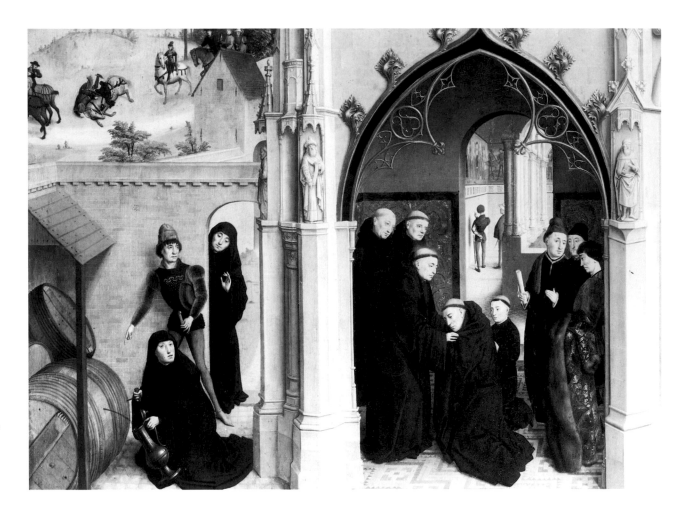

FIGURE 13. Attributed to Simon Marmion, *Scenes from the Life of Saint Bertin* (detail), completed by 1459. Wing from the altarpiece of Saint Bertin in Saint Omer. Berlin, Gemaldegalerie, Staatliche Museen Preussicher Kulturbesitz. Photographer: Jörg P. Anders.

which this manuscript preceded the execution of *The Visions of Tondal*.) In the background of the same miniature, the soul of the emperor appears on a hillside with an angel (fig. 12). The placement of the two figures anticipates the similar motif of the soul of Tondal with his guardian angel (pl. 3). The angel holds the hand of the anxious soul of Lothar and points to a valley where men are burning in hell. He offers a warning, just as Tondal's guardian shows his soul the infernal, often fiery punishments reserved for various sins. Still, in *La fleur des histoires* the fires of hell are represented more schematically, without the vividness or verisimilitude of the later manuscript. The greater naturalism of *The Visions of Tondal* was a key development of Marmion's career; this development is a theme to which we shall return.

A similar sense of psychological engagement occurs in what may be Marmion's most important painting, the elaborate wings from the altarpiece of the Abbey of Saint Bertin in Saint Omer, not far from Valenciennes (figs. 13, 14). Completed by 1459, a number of years after *La fleur des histoires* and fifteen years before *The Visions of Tondal*, the two wings relate events from the life of Saint Bertin, who was the abbey's founder and patron. Most of the scenes show three or more figures, such as the miracle of the saint at the wine barrel and his entrance into the monastery (fig. 13). The narratives are conveyed lucidly

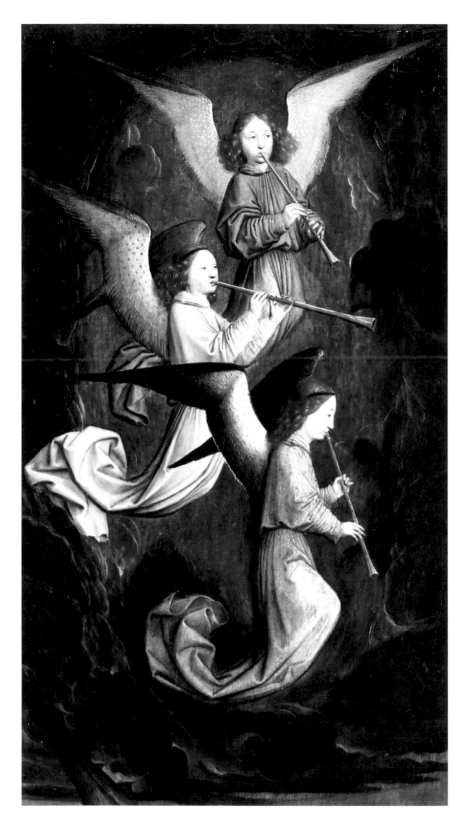

FIGURE 14. Attributed to Simon Marmion, *Angels* (detail), completed by
1459. Panel from the altarpiece of Saint Bertin in Saint Omer. London, National Gallery.

through gesture, glance, and movement. When Saint Bertin is received in the monastery, the artist shows the monks' complete involvement in the event. We have seen this dramatic engagement, too, in the opening miniature of *The Visions of Tondal* (pl. 1). The sidelong glance of the man to the right of Tondal recalls that of the kneeling Saint Bertin. A man behind Tondal tensely grasps the back of the bench while another raises his hand in astonishment. The latter recalls the gesture of the monk who raises his hand in the archway behind the saint.

A number of facial types in the wings of the Saint Bertin altar resemble others in *The Visions of Tondal*. The youth standing behind the saint, with his narrow, square jaw and chiseled features, recalls the man seated at the far left at Tondal's dinner party, while the high cheekbones are characteristic features in both figures. The brushed velvet sleeves of the youth call to mind the artist's fondness for depicting this material: it can be seen in Tondal's garments. Moreover, the facial type of the angel at the top of another panel from the altar (fig. 14) recalls Tondal's guardian angel (pl. 14). Another shared characteristic is the oval facial type with ruddy cheeks and blond hair that is parted in the center, drawn tight across the scalp, and is bushy around the ears. The draftsmanship of the wings and the robes in the two works is very similar. Finally, the artist lends radiance to the angels' red and yellow costumes in the Saint Bertin altarpiece by depicting them against black clouds, a technique similar to the one he used to intensify the glow of the flames against the darkness of Tondal's hell (pls. 7, 9).

Thus, the Saint Bertin altarpiece, especially in its effects of light, anticipates some of the more startling and expressive features of *The Visions of Tondal*, and the fact that Marmion was also a painter contributed to the remarkably naturalistic light effects in his miniatures. In Burgundian painting the aesthetic of naturalism had already matured in the first half of the century. Such artistic geniuses as Jan van Eyck (d. 1441), who was court artist of Philip the Good for nearly two decades, painted light, texture, and space with a new verisimilitude. These Flemish painters exploited as never before the translucency inherent in the oil medium. They became specialists in the depiction of light and its effects, and in the representation of highly reflective surfaces: rich textiles, jewels and precious stones, glistening metals, and glass. And they attempted to record subtler effects of light: an atmospheric haze, the sheen of pearly flesh, the transparency of a drop of water, and even fire. Many of these qualities are evident already in the altar wings of Saint Bertin, especially the quality of light in the dimly lit interior spaces and the subtly atmospheric landscapes. In his representations of these subjects, it is clear that Marmion's art was influenced as much by the great painters such as Rogier van der Weyden and Dieric Bouts as by other illuminators.

In the Burgundian Low Countries, artists frequently worked in a variety of media, as the documents concerning Marmion clearly demonstrate. Although his surviving works and the evidence of his reputation indicate that he was primarily an illuminator, he seems to have made or supervised more paintings than most other illuminators of his day. Due not only to his talent but to his training as a painter, Marmion was more sophisticated than the broad array of illuminators in the service of Philip the Good. This is evident in such paintings as the Saint Bertin altarpiece as well as in the fully mature illuminations in *The Visions of Tondal*. One may contrast the expressive figures in the opening miniatures of *The Visions of Tondal* (pls. 1 and 2) with the figures of Girart de Roussillon and Bertha in a miniature in the *Histoire de Charles Martel* in the J. Paul Getty Museum, illuminated by Loyset Liédet, one of the favorite illuminators of Philip the Good (fig. 5). In Marmion's miniatures one finds greater subtlety and refinement in

the handling of color, which may be observed in the delicate tonal harmonies of violet, gray, and silver set against gold and green in *The Joy of the Faithfully Married* (pl. 17); but one also finds an interest in atmospheric effects that is lacking in Liédet's work. This last characteristic is one of Marmion's most important achievements.

The miniatures of hell in *The Visions of Tondal* show the triumph of naturalism in Marmion's art. Significantly, these eleven miniatures comprise the most naturalistic and evocative cycle of infernal imagery before Hieronymous Bosch's great altar paintings later in the century. Prior to *The Visions of Tondal*, the most naturalistic depictions of the fires of hell had appeared not in miniatures but in paintings. We have seen how the view of hell in *La fleur des histoires* appears schematic in relationship to *The Visions of Tondal*. The work of Liédet and other illuminators of the time of Philip the Good is also less developed. Significantly, the most vivid and hauntingly beautiful treatments of hell up to this time had appeared in altarpieces by Jan van Eyck, Rogier van der Weyden, Dieric Bouts, and Hans Memling. These artists depicted hell and paradise, for example, in scenes of the Last Judgment. In Bouts' diptych of *Paradise* and *Hell* (figs. 15, 16), the dark smoke that rises over the mountains and the glowing yellow light on the horizon prove that painters were already successfully exploring the representation of transparent and ephemeral substances. Indeed, the figure of Tondal's guardian angel in the visit to *King Conchober and King Donatus* (pl. 16) recalls the angel at the entrance to paradise in Bouts' painting: both are viewed from the back, and the thin naked souls are also similar physical types. Thus, familiarity with such paintings as Bouts' diptych seems a more logical explanation for Marmion's inspiration than contemporary miniatures. Although we cannot document Marmion's travels, it seems likely that he was familiar with the towns of the Burgundian Low Countries and some of their artistic treasures. He illuminated manuscripts that were written in the Flemish cities of Ghent and Bruges, and he could easily have traveled to them or to the towns of Brabant; Bouts resided in Louvain. Whatever the case, scholars have generally agreed that the art of Bouts influenced Marmion's.

While such paintings as Bouts' are the most sophisticated forerunners of Marmion's scenes of hell, the illuminator's achievement surpasses that of the painters of his day in several respects. To give the hellfire its glow, the flames their flicker, and the miniatures their immediacy, he pushed his medium to its limits. Painters working in the oil medium did not achieve the same verisimilitude in depicting fire. Moreover, Marmion's sensitivity to color and to the relationships among colors, especially the ways they enhance one another by juxtaposition, is one of his finest artistic achievements, earning for him a special place among Flemish artists of the fifteenth century.

The sophistication of the hell scenes in *The Visions of Tondal* not only attests to the continuing growth of Marmion as an artist but also reflects the artistic ferment of the 1470s. This was a crucial decade in the history of Burgundian illumination due to an emerging trend in which the naturalism of Flemish painting was adapted to the book. During the 1470s a new generation of manuscript illuminators appeared at the Burgundian court, and for these artists the faithful representation of the visible world was an artistic credo. Inspired by painters such as Hugo van der Goes and Joos van Ghent, these illuminators reached artistic heights not seen previously in the Burgundian Netherlands. *The Visions of Tondal* is a key example of the sophisticated naturalism and artistic refinement in Flemish manuscript illumination of this time.

The artists of this new generation introduced a new style of book decoration that revolutionized the

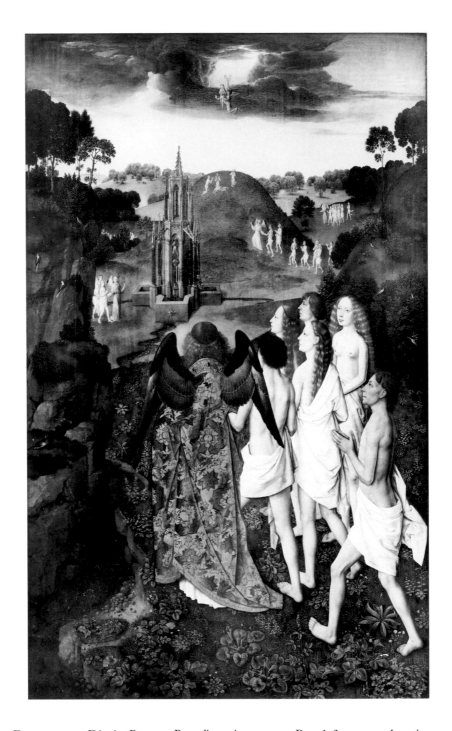

FIGURE 15. Dieric Bouts, *Paradise*, circa 1470. Panel from an altarpiece. Lille, Palais des Beaux-Arts. Photograph courtesy Réunion des Musées Nationaux, Paris.

appearance of Flemish manuscripts. The border decorations, which feature some of the same motifs that we see in the borders of *The Visions of Tondal*, were now painted on brightly colored backgrounds. The younger artists, who seem not to have produced paintings, introduced many more flowers and other natural forms, presenting them as if they had been casually strewn across the borders (see fig. 17). Each miniature has a painted shadow, enhancing the illusion of three-dimensional reality. The artists had learned this precision and verisimilitude from the Flemish paintings of the period.

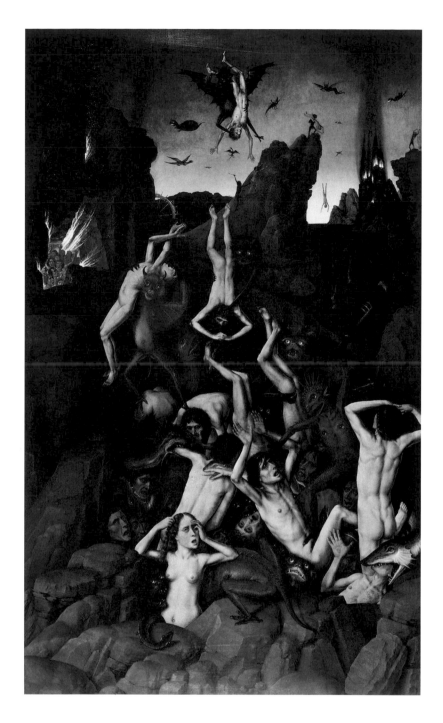

FIGURE 16. Dieric Bouts, *Hell*, circa 1470. Panel from an altarpiece. Lille, Palais des Beaux-Arts (on loan from the Musée du Louvre). Photograph courtesy Réunion des Musées Nationaux, Paris.

In one of the most brilliant miniatures in this new style, probably painted not long after *The Visions of Tondal*, the richness and subtlety of atmospheric effects are truly startling. The miniatures of the *Crucifixion* and *Christ Nailed to the Cross* (fig. 18), found in a magnificent book of hours that may have been made for Mary of Burgundy, the daughter of Charles the Bold, are monuments in the history of Flemish illumination. They were inspired by an altarpiece of a few years before, painted by Joos van Ghent. But they do not merely imitate their source; they rival it in expressiveness and in naturalism. The artist who pro-

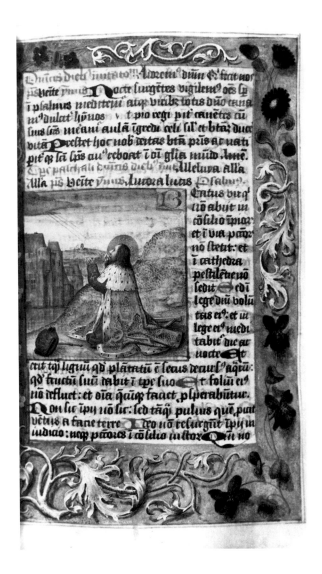

FIGURE 17. The Master of Mary of Burgundy, *King David in Prayer*, 1477. Brussels, Bibliothèque Royale, Ms. IV 860, fol. 36.

duced these miniatures is known as the Master of Mary of Burgundy. Like Simon Marmion, he was inspired by the challenge of representing the shapeless and mutable. The aerial perspective, or manner in which atmosphere tends to dissolve form in the distance and thereby convey the illusion of deep spatial recession, is brilliantly executed. It is not surprising that this artist and Marmion collaborated on a major book of hours during the 1480s. Marmion supplied the Master of Mary of Burgundy with a handful of miniatures for this lavishly decorated book (now in Berlin and Madrid), which contains illusionistic borders like those described above.

In this way the aesthetic course of Flemish manuscript illumination was established for the next two generations. Scholars have previously given nearly all the credit for this development to the Master of Mary of Burgundy and his collaborators, who did carry naturalism further. But it was Marmion who in his own exploration of pictorial naturalism as an illuminator helped pave the way for the aesthetic revolution that took place.

The sophistication of Marmion's narrative style is further reflected in a companion volume to *The

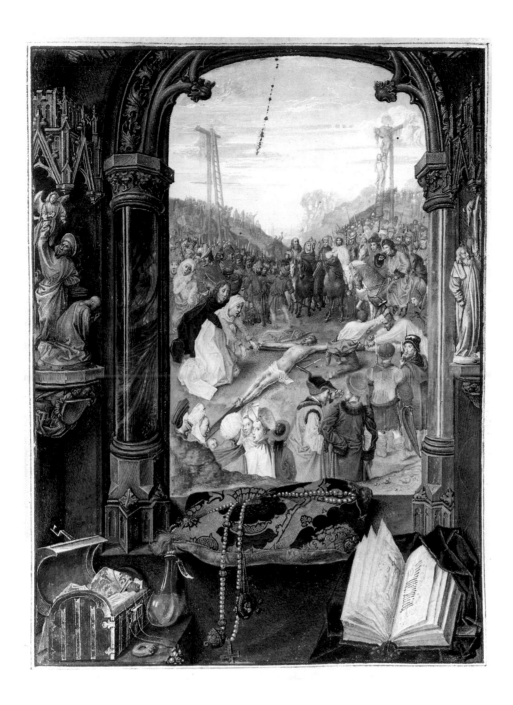

FIGURE 18. The Master of Mary of Burgundy, *Christ Nailed to the Cross*. Book of hours, late 1470s. Vienna, Oesterreichisches Nationalbibliothek, codex 1857, fol. 43v.

Visions of Tondal entitled *The Vision of the Soul of Guy de Thurno*. Its story relates another mystical experience, and the unusual miniature in the manuscript depicts a conversation with a ghost (fig. 19). David Aubert completed the writing of *The Vision of the Soul of Guy de Thurno* on February 1, 1474, and *The Visions of Tondal* in March. Although they were clearly conceived as separate books—each has its own colophon—they may have been bound together since Margaret's time. The story concerns Guy de Thurno, a wealthy citizen of Verona, whose ghost returns to haunt his spouse. She enlists the aid of a priest, and a debate ensues between the priest and the ghost concerning the nature of the afterlife.

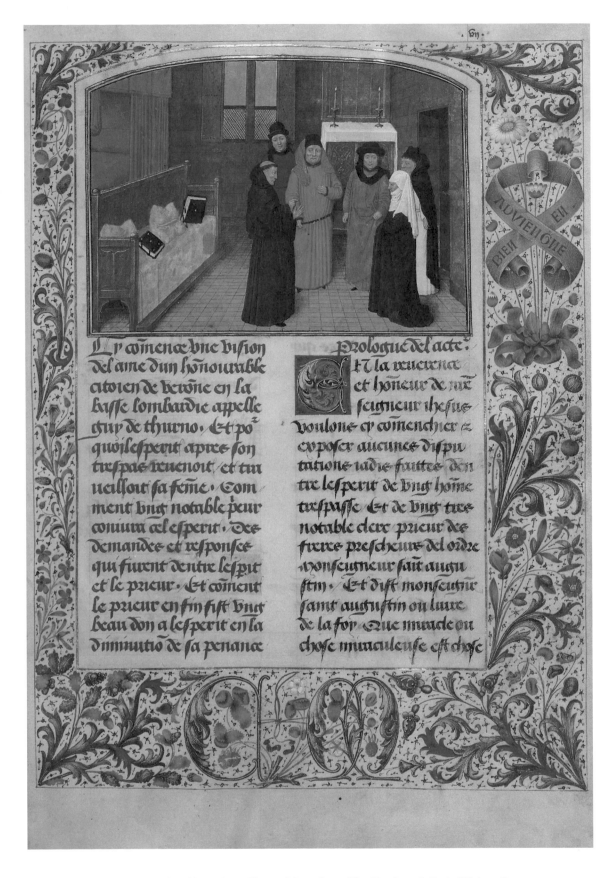

FIGURE 19. Attributed to Simon Marmion, *The Monk and Guy's Widow Converse with the Soul of Guy de Thurno*. *The Vision of the Soul of Guy de Thurno*, written by David Aubert, 1474. Malibu, J. Paul Getty Museum, Ms. 31, fol. 7.

In the miniature, Marmion shows us the priest concentrating intently on the debate, while the by-standers, who are unable to see the ghost, show their confusion and surprise at the event taking place before them. The grimacing citizen to the right of the priest is particularly unsettled, while the man behind him is absorbed by the supernatural event. The artist focuses our attention on the two figures by isolating them in one part of the room, where they are framed by elements of the architecture and by furnishings. Further, by the use of symmetry and the pairing of figures at the front of the room, the artist makes the viewer—by implication—a participant in the scene. This and the naturalism of the depiction make the psychological drama all the more compelling.

The two illuminated *Visions* represent the most evocative and unusual imagery in the career of Marmion and perhaps also within Flemish illumination of the late fifteenth century. Marmion himself never again received a like commission. After the death of Charles the Bold in 1477, commissions from the court for the grand chronicles and major literary and visionary texts declined greatly. During the 1480s, like other major illuminators, Marmion turned increasingly to the decoration of books of hours. The most popular text of the late medieval period, the book of hours is a collection of prayers recited in a daily cycle of private devotions. Illuminated books of hours were a manuscript painter's bread and butter, even for an artist of Marmion's stature. By the 1480s, he had already been painting them for several decades.

Despite the largely standardized subject matter of books of hours, Marmion continued to develop new styles of illumination. In a widely influential book of hours in Naples known as *La Flora*, the artist adapted the half-length format of devotional painting to his miniatures, giving the figures even greater immediacy and offering the viewer a more intimate experience of biblical narratives. The half-length miniatures offer a vividness and directness that Marmion had achieved in the scenes of Tondal's hell in quite a different way. Derived from the conventions of Flemish painting, the half-length format is the most innovative feature of books of hours produced in the 1480s.

In the cycle of about twenty miniatures by Marmion that are inserted in *La Flora*, the large, blocklike heads of the figures seem at first unlike anything that we have seen. The facial types, however, show familiar traits: the high cheekbones, heavy eyelashes, wide, long noses, and distinctively arched brows. Moreover, some of the most beautiful features of *The Visions of Tondal*, such as the distinctive color combinations of paradise, recur throughout this manuscript, perhaps because they are so appropriate to the sacred world of New Testament narrative. The colors in *The Glory of Good Monks and Nuns* (pl. 19)—salmon, soft blue, violet, white, bright green, and gold—are found throughout *La Flora*. These same colors appear together in the miniature of *Christ Among the Doctors* (fig. 20), and although the costumes in this scene differ from what we have seen until now, one notices the artist's expressive use of glance, gesture, and movement to show the crowd's reactions to Christ. Even the facial types of the bearded Pharisees resemble those of the martyrs whom Tondal views on his journey (pl. 18). Elsewhere in *La Flora*, in the half-length miniature of *Saint James the Greater Preaching* (fig. 21), one finds salmon, soft blue, and bright green, and also the golden skies of the purgatory and paradise scenes of *The Visions of Tondal* (e.g., pl. 14). The hat of one listener even has the same salmon-colored, brushed velvet that Tondal wears (pl. 1).

Marmion favored the half-length format throughout the 1480s. The Getty Museum owns an unpublished half-length miniature attributed to him from a book of hours, *Saint Bernard's Vision of the Virgo Lactans* (fig. 22). The Madonna and Child are reminiscent of the half-length devotional paintings of this

FIGURE 20. Attributed to Simon Marmion, *Christ Among the Doctors*. Book of hours (*La Flora*), 1480s. Naples, Biblioteca Nazionale, Ms. I B 5, fol. 289v.

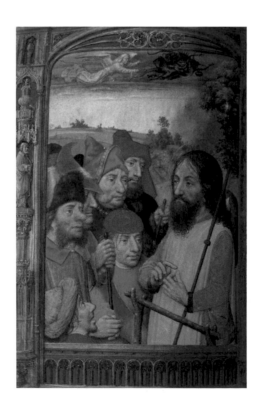

FIGURE 21. Attributed to Simon Marmion, *Saint James the Greater Preaching*. Book of hours (*La Flora*), 1480s. Naples, Biblioteca Nazionale, Ms. I B 5, fol. 318v.

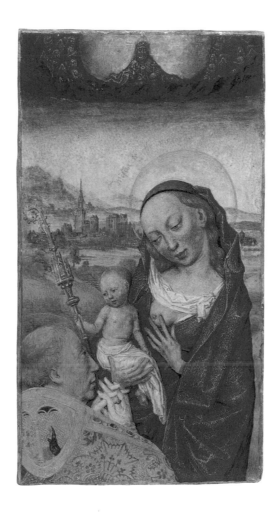

FIGURE 22. Attributed to Simon Marmion, *Saint Bernard's Vision of the Virgo Lactans*. Detached miniature from a prayer book, 1480s. Malibu, J. Paul Getty Museum, Ms. 32.

theme that were painted by Rogier van der Weyden and Dieric Bouts, but the facial type of the Madonna, with the sweeping eyelashes, high cheekbones, ruddy cheeks, and hair drawn back tightly on her scalp, is unmistakably Marmion's. The finely painted flesh tones, built up of many individual brushstrokes, and the heads that are somewhat large for their bodies, recall miniatures in *La Flora*.

These selected examples show us that the career of Simon Marmion was extraordinarily varied. He illustrated a broad range of texts and subject matter: secular, devotional, visionary. He worked on diminutive prayer books and private devotional books, along with massive chronicles and altarpieces. From the beginning of his career, he showed the gift of a natural storyteller. He conveys to us the thoughts of his characters and their concerns, and uses this ability to dramatic ends. Since the naturalism of Flemish painting was more sophisticated and refined than in manuscript illumination at mid-century, it is not surprising that Marmion also introduced to manuscripts some of the painter's sensitivity to light, color, and texture. Nevertheless, certain characteristics—such as the facial types, the overall blond tonalities of many of his works, and the interest in pastel colors in the last decades of his career—distinguish his pictorial style from that of his contemporaries.

Within the development of Flemish naturalism, Simon Marmion's miniatures in *The Visions of Tondal*

represent a pinnacle. In them Marmion was concerned not only with representing solid, three-dimensional forms, a primary concern of painters of the day, but also with depicting air, smoke, and flame, less tangible materials whose shapes are in flux. Moreover, in this manuscript he sought to represent not just light's reflection but a more challenging illusion, the radiance of the light source itself. Among the most original compositions of the fifteenth century, the miniatures in *The Visions of Tondal* reflect the burgeoning concern of fifteenth-century illuminators with verisimilitude. Marmion's example almost certainly inspired a younger generation of illuminators, who were forming their styles about this time, to explore these aspects of naturalism. Small wonder that the artist from Valenciennes came to be called "the prince of illumination."

Thomas Kren

THE VISIONS OF TONDAL
TEXT AND MINIATURES

Excerpted from a Translation by Madeleine McDermott and Roger S. Wieck

HERE BEGINS THE BOOK
about a knight and great nobleman
in Ireland who was called Lord Tondal.
It is contained in this book how his soul
left his body, how he saw and experienced
the torments of Hell, as well as the
pains of Purgatory, after which the
angel showed him the glory and
nobility of Paradise.
Then his soul was put back into
his body. This was shown to him
to chastise him and make him retreat
from his perverse life.

All illustrations are approximately the same size as the miniatures themselves,
except for the full-page reproductions, which are reduced.

PLATE 1. *Tondal Suffers a Seizure at Dinner (fol. 7)*
Lord Tondal was young of age and of a very noble
house. He was tall and of a strong build, jolly, and
had the bearing of a handsome and happy man. He
was reared on fine food and dressed with fine care.
He was most courageous and bold. But he had one
thing about him, which I cannot mention without
sadness, that he was so confident in his youth, in his
good looks, and in his strength, that to the salvation
of his soul he never gave a thought. He despised the
Holy Church and would hear nothing about God's
poor. Yet to jesters and to minstrels he would give
extravagantly from his wealth.

This noble knight had many good friends. Among
them was one who owed him a debt each year for
the service of three horses, and a certain time came
when this friend had to pay for these expenses. The
knight waited until the time for payment had come,
and when the day passed, the knight went one
morning to the house of his friend, who received
him humbly. Tondal spoke to him of why he had
come, to which his friend responded that he was a
little short of money at the moment. When the
knight heard this he was very cross. His host took
great pains to mollify Tondal and asked him to stay
on and to eat once more with him because he held
him in much esteem and love. When Lord Tondal
saw that he could not refuse the entreaties of his
friend, he stayed. Thereupon the knight set down a
heavy halberd that he always carried and sat to eat
with his host.

All of a sudden, Tondal was struck in his right arm,
which he had extended toward a platter of food to
help himself, and he could not withdraw it. Then he
began to tremble and shiver very frighteningly. He
entrusted his halberd, which he had set aside, to the
wife of his companion, saying that he indeed saw that
he was going to die.

VIENONE

BIEN EN A[...]

Cy commence le liure
dun cheualier et grant
seigneur en yrlande et
fut nomme messire tondal
Et est contenu en cestuy
liure comment son ame
partz de son corps comment
elle bey et sentz les tour
mens denfer. Et ainsi
les peines de purgatoire
Et apres langele luy
moustra la gloire et la
noblesse de paradis. Et
puis luy fut lame remise
ou corps. Et luy fut ce
moustre pour le doubter

et rature de sa peruerse
vye. Le prologue.
Que ceulx quy
leur couraige et
affection ont et
arrestent en lamour de
ce monde present trop
boulentiers escoutent et
racomptent fables et to'
exemples de vanitez si
en oublient souuent les
grans biens de paradis
et les tourmens denfer
pardurables dont ilz sont
malement decheuz maiz
ceulx quy ayment dieu

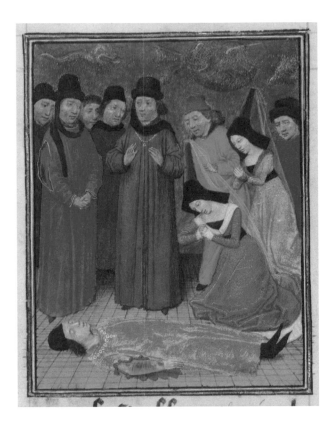

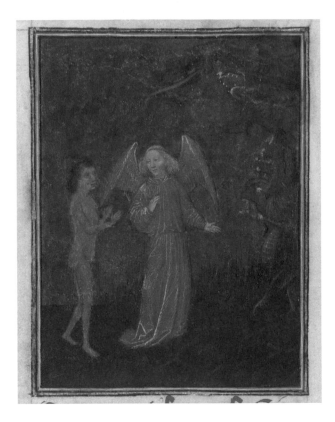

PLATE 2. *Tondal Appears Dead (fol. 11)*

Tondal had no sooner said these words than he fell
dead under the table without any further movement
of foot or hand. All the signs of a dead man manifested
themselves on him: his eyes rolled, his nose was
pinched, his lips grew thin, his chin receded, and his
arms and legs grew stiff. The people of the house,
at the cry of their master, ran in and removed the
table. When they saw him stretched out dead, they
were all shocked. When the people of the city were
informed, they were greatly stunned and the whole
city was much troubled by the death of the knight.
His body showed no sign of life, except for a little
warmth that could be felt on his chest when they
brought the body to the window. Because of this bit
of warmth, he was not buried.

 When the soul of Tondal saw that his body was
nearing its end and that he had to leave it, his mis-
deeds were revealed to him, at which he took great
fright. He could well see the hard predicament he
was facing. He wanted to leave his body, but he did
not dare. He saw coming an awful and horrifying
multitude of devils who soon invaded the house as
well as the air all over the city, saying, "Let us sing to
this creature a song of painful death. He is meat for
the endless fire because during his whole life he
cherished the life that leads to darkness." The
demons gnashed their teeth, screaming, "Oh you
miserable and unhappy thing, where now are your
pride, your lust, and your vanities that you used to
love so much? Why do you not sing, dance, and make
merry as you were used to doing? Where now are
your earthly friends whom you used to love so much?
Why do you not call to them in this danger in which
you now find yourself?"

PLATE 3. *Tondal's Guardian Angel Comes to His Aid
(fol. 11v)*

When the soul of Tondal heard the accusations that
the devils of Hell were declaring against him, he was
so shocked that he did not know what to say or think.
But Jesus Christ, Our Lord, delivered the soul from
his peril and sent one of His angels to comfort him.
When the angel drew near to him, he called him
by his name and said, "Tondal, God keep you! What
are you doing here in this place?" Then the sad soul
began to cry and said to the angel, who was far
more beautiful than any mortal creature, "Poor
unhappy me! In truth, goodly sire, the frightening
pains of Hell and the hard passage into death have
assailed me harshly on all sides." To which the angel
said, "You now call me goodly sire, I who have always
been with you but whom you never once deigned to
call by that name." Pointing to one of the fiends who,
ahead of all the others, was assailing him, the angel
said, "The counsel of this one you followed daily, but
mine you always despised. But since Our Lord
dispenses more of His mercy than His justice, His
inestimable goodness will not fail you, no matter how
much you have not deserved it. Be certain that you
will suffer little torment compared to your misdeeds.
Follow me and remain close to me, and keep in
your heart all the things that you will see." Thereupon
the soul of Tondal, in great distress, left his body
and drew near to the angel. When the devils thought
they could seize the poor and suffering soul, to
make him endure what they had promised him, but
were not able to lay hands on him, they began to
blaspheme the name of God. As soon as their words
were finished, they left together in a great frenzy,
and where they had been a great stench lingered.

40

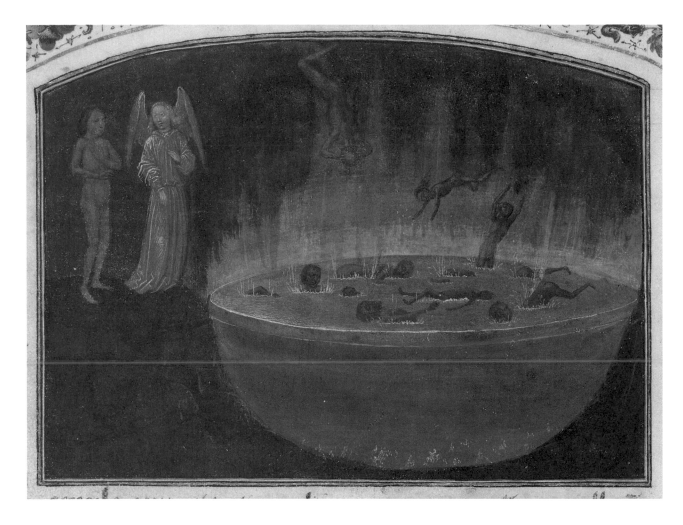

PLATE 4. *The Valley of Homicides (fol. 13v)*

After the angel and the poor soul had gone a long way together, they arrived at a great valley, very frightening and dark, vast and very gloomy. This valley was very deep, full of burning coals. Over the valley was a round lid of iron, all burning and awesomely massive. On top of this lid was falling a great multitude of damned souls who were burned and roasted there and were then liquefied and strained through the burning lid like a sauce strained through a canvas sieve. From there they would fall onto the fire, from whence their torments were continuously renewed.

The soul of Tondal was completely overwhelmed and said to the angel, "Dear master, please tell me, what did these poor souls do wrong while in the world for which I now see them so cruelly tormented?" To this the angel answered, "Such is the reward for homicides and for those who have killed father or mother, sisters or brothers. This is then the first torment. After these torments they will be taken to much greater ones." Then the soul said, "Dear master, must I endure these torments?" "You have more than deserved them," responded the angel, "but for the present moment you will not suffer them. Let us proceed, for we still have a long and difficult way to go."

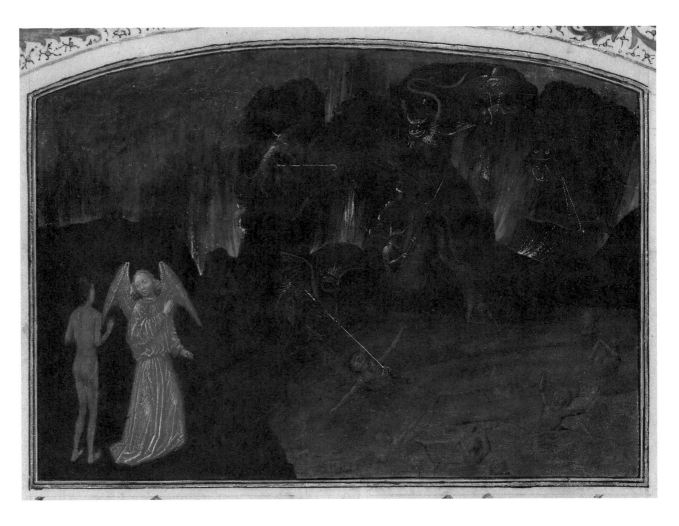

PLATE 5. *The Mountain of Unbelievers and Heretics*
(fol. 14v)

The angel and the soul of Tondal went farther and arrived at the foot of a mountain, which was very large and horrible. At that place there was a very narrow path. On one side of the mountain there was a great fire of sulphur, very horribly stinking. And on the other side were great icy ponds and lakes, winds and storms very furious and never seen by human beings. All around and in all parts of this mountain were the infernal fiends. They held in their hands big iron hooks and forks and large barbed iron bars and grappling hooks, red-hot and very sharp, with which they would attack and ensnare the souls who were walking there. Pitilessly they would chase the souls down into the deepest torment amid great and horrible explosions. When they had tormented them in those furnaces for a long time, they would drag them up again with their burning hooks and throw them into deep abysses full of water, snow, and freezing-cold, jagged ice. Whenever a soul complained of too much heat, he was thrown into very harsh cold, where he was worse off than before. Thus, from bad to worse, the souls were treated without hope of ever leaving.

When the soul of Knight Tondal saw so many and such various torments he said to the angel, "For God's sake, please do not abandon me because I realize quite clearly that these evil spirits would like nothing better than to apprehend me and throw me into these torments." To which the angel replied, "Make sure you remain close behind me and go where I walk." The good angel then started on his way, going first, and the soul immediately followed him, and thus they negotiated this narrow passage easily.

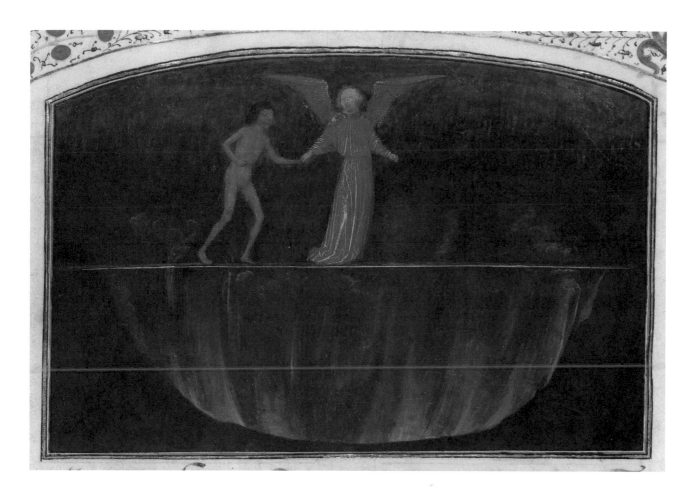

PLATE 6. *The Valley of the Perversely Proud and Presumptuous (fol. 15v)*

Thus the good angel and the soul of the Knight Tondal arrived at a great valley. This valley was so very deep that the soul of the Knight Tondal could not even see the bottom. But he was hearing quite clearly, from below, a great noise and an awe-inspiring thunder, as if from a great conflagration and a great wind, the one struggling against the other. Out of this abyss arose a stench of sulphur and other corruption, as if from carrion. There could be heard a great multitude of souls shouting very hideously, moaning and complaining. Spanning the top of this noxious valley stretched a very long bridge, much more than one thousand feet in length, but in width barely one foot. From this bridge the soul of Tondal saw many souls tumbling into the deep valley. He saw that no one was able to cross safely over the bridge,

and he spoke to the angel in great fear, "Oh my dear master, for God's sake, have pity on me! Who would be able to deliver me from this mortal peril?" At this the good angel looked at him very tenderly and told him, "Do not have any fear, for you will be delivered and spared this passage and the torments that are assigned here. But you will have to undergo some pain later on." Thereupon the angel took him by the hand and walked ahead along the bridge, and the soul of the knight followed after him without receiving any harm. Then he said to the angel, "Will you please tell me for what kind of people these torments here are prepared?" The angel answered, "Indeed, these are the torments for the proud, the ungrateful, and the presumptuous, who during their time on earth despised the poor and the commandments of God."

PLATE 7. *The Beast Acheron, Devourer of the Avaricious (fol. 17)*

When they had gone a long time in great gloom of darkness, the spirit perceived from afar a beast so huge that no one would believe it. The spirit of the knight had never even seen a mountain of that size. The beast had two eyes such that they resembled two large embers, all ablaze. Indeed, its mouth was so cavernous and so wide that ten thousand knights, armed and on their horses, could have entered it at the same time all in a single row. This horrible beast had in its jaw two big devils. One of them had his head forced into the upper teeth and onto the lower teeth were affixed his feet; and the other devil was in the opposite position. A fire of wondrous size, which could never be extinguished, issued forth from that mouth, dividing itself into three parts. The spirit of the knight heard the painful cries of the unfortunate souls who, inside the hideous beast, were shouting their strident laments in such great numbers that no one could count them. In front of the beast was a great number of devils who forced the desolate souls to go inside while cruelly attacking, beating, and tormenting them. Trembling and weeping, Tondal said to the angel, "Why are we going closer?" To which the angel answered, "We cannot go by any other way than that which we have started, and nobody can escape this torment unless he is one of the elect of God. This beast is named Acheron, who devours all the avaricious."

Then the angel suddenly disappeared. As soon as the fiends saw the soul alone, they dragged him into the huge and horrible jaws of the beast. The soul underwent the assaults of frenzied lions, of mad dogs, the bites of serpents and of other horrible beasts that he could not recognize. Devils beat him with big clubs, fire burned him, cold bit him, sulphur suffocated him. While the soul was in these torments he did not know what to say or what to do, except to lament and accuse himself of his sins.

While thinking this way about his deeds, he found himself outside of the belly and jaws of that horrible beast—but he did not know how it happened. He opened his eyes a little and saw at his side the angel, a fact that made him very joyous. He said to the angel, "What could I repay to my God and Redeemer for this great beneficence He granted me? What thanks shall I be able to give Him that would be worthy in comparison to this gift?" Then the angel said to him, "As you have just said, the forgiveness of the most high Creator is far more powerful than all your transgressions could ever be. But in the end, He will render to each what is due according to his deserts. For that reason, guard yourself carefully when you return to your body in the world, so that you will never again deserve these pains and torments."

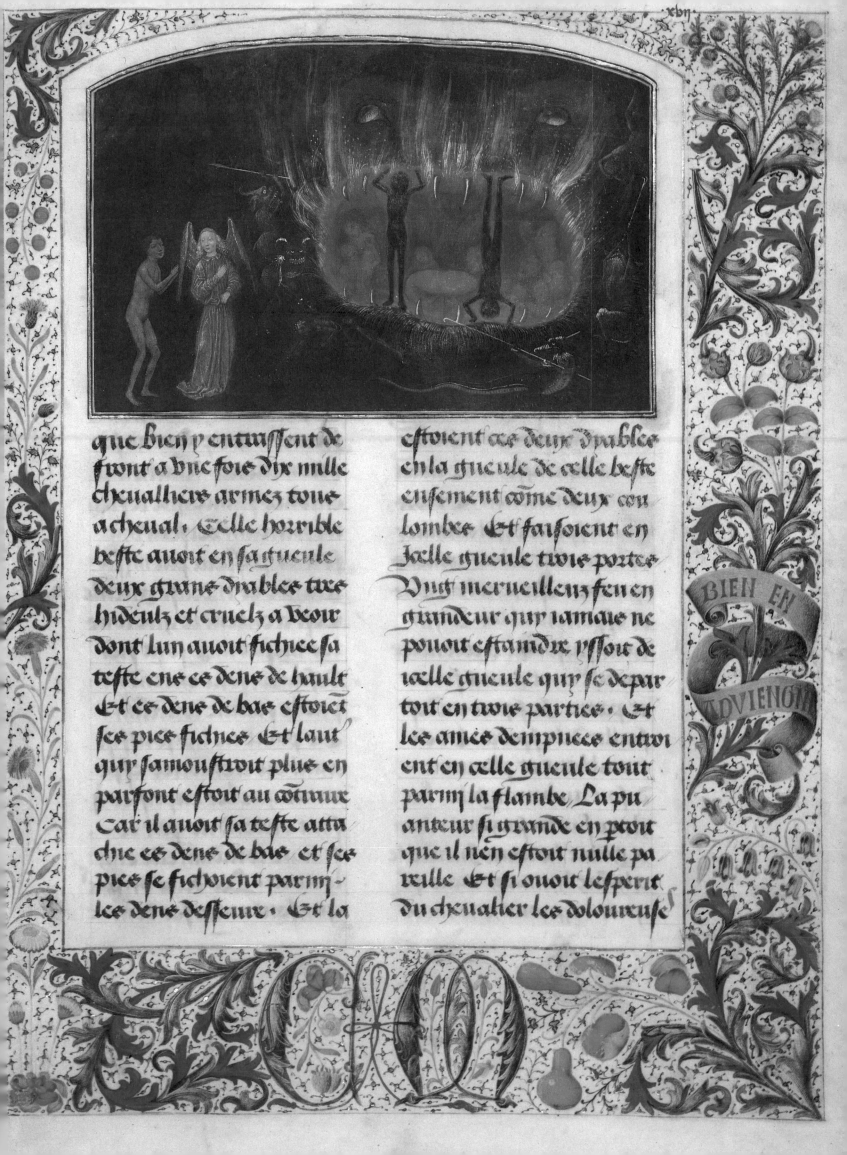

que bien y entraissent de
front a vne fois dix mille
cheualliers armez tous
a cheual. Celle horrible
beste auoit en sa gueule
deux grans diables tres
hideulx et cruelz a veoir
dont lun auoit fichiee sa
teste en ce dens de hault
et ce dens de bas estoient
ses piez fichies Et laut
quy samoustroit plus en
parfont estoit au continue
car il auoit sa teste atta
chie es dens de bas et ses
piez se fichoient parmy
les dens dessure. Et la

estoient ces deux diables
en la gueule de celle beste
ensement comme deux cou
lombes Et faisoient en
icelle gueule trois portes
Vng merueilleux feu en
grandeur quy iamais ne
pouoit estaindre yssoit de
icelle gueule quy se depar
toit en trois parties. Et
les ames dempnees entroi
ent en celle gueule tout
parmy la flambe La pu
anteur si grande en yout
que il nen estoit nulle pa
reille Et si ouoit lesperit
du cheualier les douloureuse

BIEN EN
ADVIENOIT

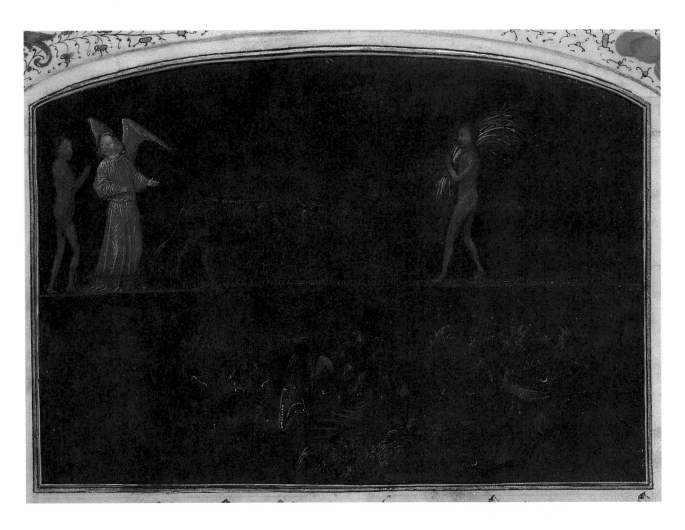

PLATE 8. *The Nail-Studded Bridge for Thieves and Robbers (fol. 20)*

The soul of the Knight Tondal was very weak after making this admission, but he stood up and struggled to follow the angel. While they were going at a good pace, the soul looked ahead and saw from afar a huge lake. In this body of water lived a great number of awesome beasts who never ceased to roar and bellow. Above this pool was a bridge, very long and narrow, the length of which was no less than three thousand paces, but its width was only the palm of one hand. The span was all embedded with sharp iron nails. The horrible beasts would congregate under the bridge, awaiting their prey. Fire and flame spouted from their jaws and their nostrils in such abundance that the whole lake boiled violently. Upon the bridge came a soul laden with sheaves of wheat, wailing because of the torment to his feet, but not wanting to let himself fall into the lake where he made out the jaws of the inhuman beasts who awaited him.

And the angel said to Tondal, "Know that this pain is contrived for all those who commit larceny, big or small. Let us hurry, for we must cross this bridge. But I shall not cross with you. Nor will you cross it alone. You must lead a wild cow with you." Then the soul started to cry very hard, saying, "Alas, how will I be able to take the cow over?" "Remember," said the angel, "how you once stole a cow from one of your friends?" "Master," answered the soul, "I gave it back." "Only," said the angel, "when you were no longer able to keep it. Since the animal was returned, you will not suffer too great a torment."

When the soul saw that he could not escape, he took the cow by its rope and struggled hard to pull it along. Thereupon the horrible beasts in the lake came under the bridge to wait for their prey. When the soul and the cow reached the middle of the bridge, they saw coming from the other direction that soul who was laden with sheaves of wheat. Thus the two souls encountered each other, crying a great deal. Neither one nor the other could retreat or look behind. After they had been facing each other for a long time, they discovered that one had passed the other, but they did not know how they had crossed the bridge. When the soul of the knight found the angel, he showed him his feet, complaining that he could not walk anymore. The angel said to him, "Remember how in your life your feet were ready to carry you to those places where you would sin?" Then the angel touched Tondal's feet with his hand, and they were cured immediately.

46

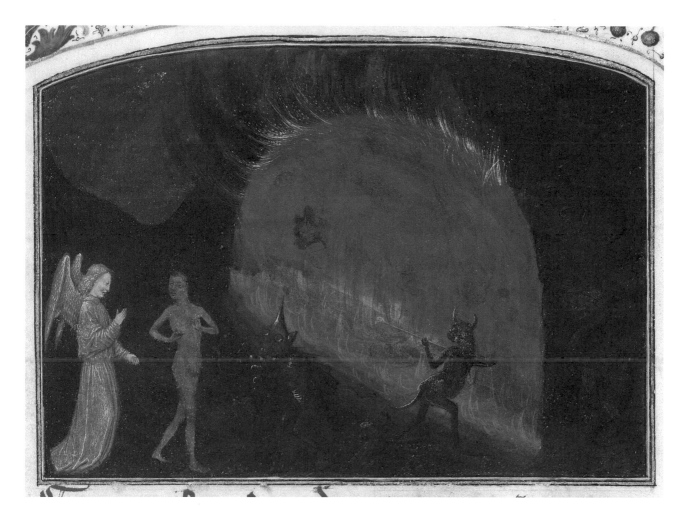

PLATE 9. *The House of Phristinus: Punishment for Gluttons and Fornicators (fol. 21v)*

Then the angel walked ahead and the soul said to him, "Where shall we go, dear master?" The angel answered, "A very cruel executioner named Phristinus awaits our arrival and there is no way we can avoid his residence. Even if this house is always full of guests, the master never ceases to seek souls." As they were going through the darkness, they saw a very large building, wide open, as tall as a very high mountain, and completely round, like an oven. Spewing forth from this structure was such a fire that all it reached for a thousand paces around was aflame. The angel told the soul of Tondal, "The flame that issues from this mansion will not touch you, but you must enter this house."

When they approached the building they saw tormentors, who held in their hands big swords, axes, knives, arrows, hooks, scythes, iron forks, and other cruel tools. The tormentors speared those who came before the door of the castle, and there they liked to behead all the souls, to split some in two, and, with others, to hack off their limbs. Then the angel said, "Enter this torment, because there are indeed rabid dogs that await your arrival." Then the soul began trembling, begging the angel to escape this torment. Thereupon the devils saw the soul of the knight abandoned; they surrounded him and abused him and reproached him for his sins,

dismembered him, and dragged him into the horrible fire. What more could one say about those who were in that cruel castle? There were heard only crying, moaning, and wailing with great ardor. There innumerable souls were racked by hunger but in no way could they be satisfied. The greatest torment these souls were suffering was in their genitals, which were rotting and full of worms.

When the soul of the Knight Tondal had endured this at length, he concluded that he had well deserved his torments. But, at the will of Our Lord, he found himself outside of that torment. Still in darkness, he looked and saw the radiance of the angel, whom he asked, "But where is the forgiveness of God of which Scripture says the earth is so full?" The angel then said to him, "If God would forgive all the sins committed against His commandments, why would anyone then do anything good? If you are so amazed that the souls of the just are led through torments to the eternal joy of Paradise, I will disclose to you the reason. It is because, when they have seen the pains from which they are delivered by the great kindness of God, they will more ardently love and praise their Creator. Quite in the same way, the souls of sinners, who deserve the pains of Hell, are first taken to see the glory of the saints. When they arrive at these torments, they will be that much more distressed and desolate, for there is no greater torment than to be separated from the love of Our Lord."

47

œulz que pomt nauone
veuz · Chier sire dist lore
lame · Se tantost deuone

benir a veour la gloire des
saulrez Je te prie q̃ tãtost
passone oult œs tomene

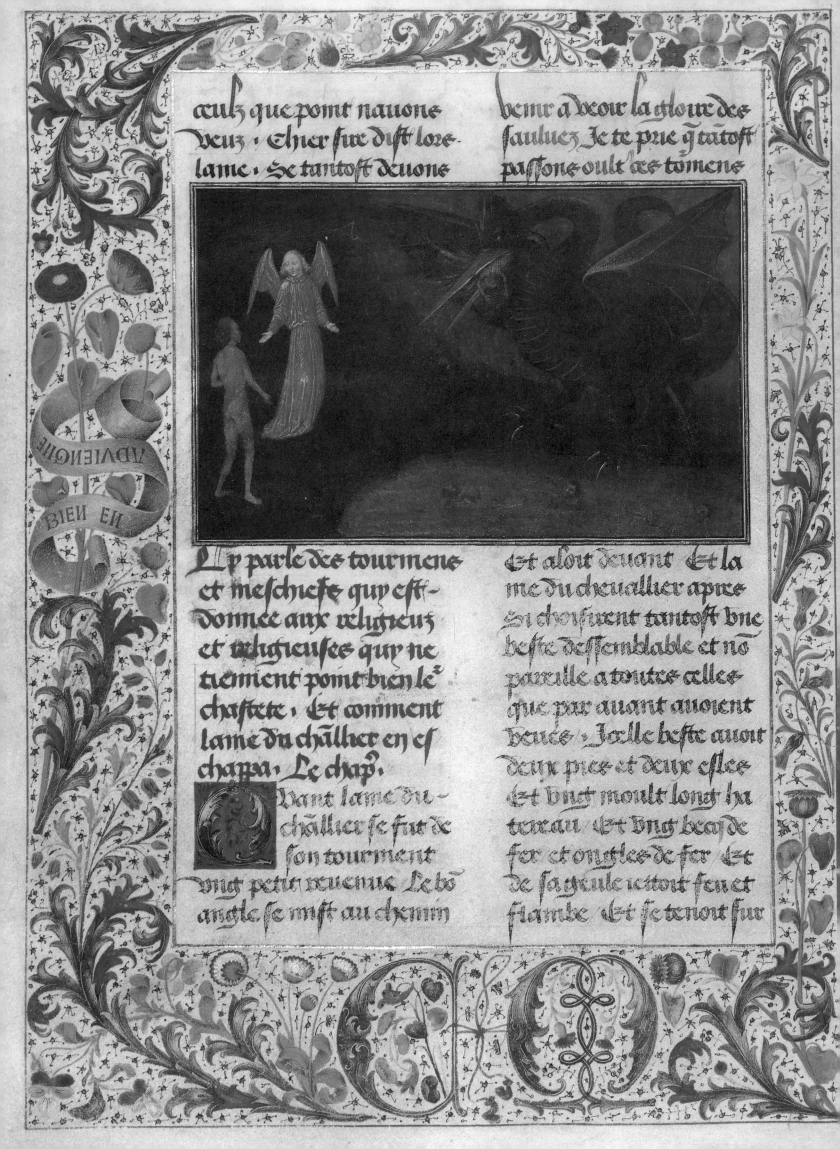

L p parle des tourmene
et meschiefs quy est
donnee aux religieuz
et religieuses quy ne
tiennent pomt bien le²
chastete · Et comment
lame du chãllier en es
chappa · Le chap̃.

Vant lame du
chãllier se fut de
son tourment
vng petit reuenue Le bõ
angle se mist au chemin

Et aloit deuant Et la
me du cheuallier apre
Si choisirent tãtost vne
beste dessemblable et nõ
pareille a toutes celles
que par auant auoient
veues / Jcelle beste auoit
deux pies et deux eslee
Et vng moult long hu
terau · Et vng bec de
fer et ongles de fer / Et
de sa ycule istoit feu et
flambe · Et se tenoit sur

PLATE 10. *The Beast That Eats Unchaste Priests and Nuns (fol. 24v)*

The angel and the soul soon came upon a beast
unlike all those they had already seen. This beast
had two feet and two wings, a very long neck, and an
iron beak and iron claws. From its jaws it breathed
fire and flame and stood upon a large pond, all frozen.
There it would devour all the souls it could reach.
When it had eaten the souls, and they had been
reduced to nothing in its belly, the beast would
defecate, dropping them onto the ice where their
torments were renewed. All the souls who were thus
thrown onto the ice were made pregnant, men as well
as women, and there awaited the time when they
would give birth. The litter they had inside them
would meantime eat at their entrails. When their
time came, they would give birth to hideous serpents,
not only through the organ nature ordained for this,
but also through their arms and feet. Each of these
serpents had an iron beak—burning, sharp, and
searing—with which they would tear open the mem-
ber from which they emerged. These serpents had
sharp and venomous tongues with which they would
suck the life out of the souls to the point of death,
a death which they continually sought. But it was in
vain, because they were dying alive and living dead.

And the angel said, "This torment is for the monks
and nuns who do not render to Our Lord what they
have promised and who think they deceive God. For
those who loved the lust that was forbidden to
them, their genitals burn and are rent by serpents. By
all the men and women who dishonor and soil their
souls through the sin of lust, this torment must be
endured. For this reason you cannot escape it, for
during your life you abandoned yourself to lust." The
fiends then came and seized the soul and delivered
him to the beast to be devoured. The anguish that
the poor soul endured inside the horrible beast and in
the frozen pond, no man in the world could imagine.
When the soul thought he was about to give birth to
serpents, he looked up and saw coming to him the
angel, who touched him, quickly cured him, and bid
him to go forward.

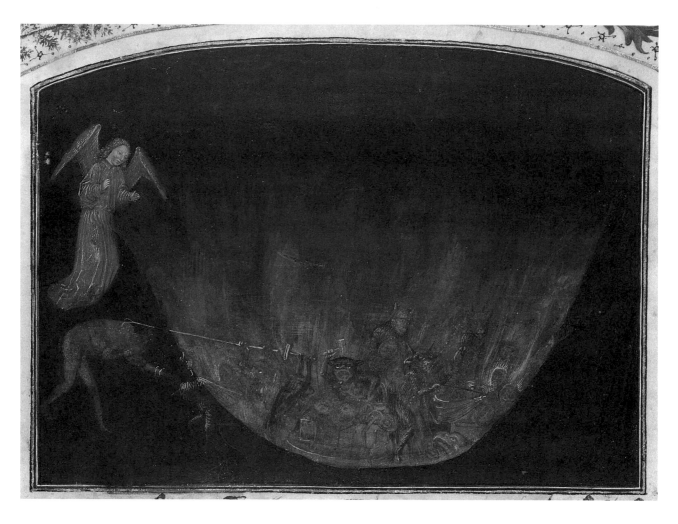

PLATE 11. *The Valley of Fires, for Those Who Commit Evil upon Evil (fol. 27)*

The angel and the soul of Knight Tondal then came to a valley that is called the Valley of Fires. There they found several forges and heard much lamentation. As they were approaching, the devils came to meet them, holding in their hands burning tongs of iron. Without a word to the angel, they grabbed the soul and threw him into a blazing furnace and pumped the bellows of the furnace, in the same way as one melts iron for casting. There, the desolate souls were cooked and recooked to the point where they were reduced to nothing. Then the devils would take them with their iron forks and place them on burning anvils. There they would forge them together with big hammers, so that twenty, or thirty, or fifty, or a hundred of them would become one mass. Tor-

menting them, the devils would say, one to the other, "Are they forged enough?" From one devil to the other, with their burning tongs they would throw and catch the souls.

While the soul of the knight was in that torment, the angel came forward to meet him as usual, dragged him out of the fire, and asked him how he was. "Were the delights and the pleasures of the flesh ever so sweet that, for their sake, you would have endured such torments?" The soul could not utter a word to this because he had no strength left to speak. The angel continued, "All the men and women whom you have seen up till now amidst these torments await there the forgiveness of Our Lord. But those who are at the bottom of Hell are judged indeed from the day and hour of their death."

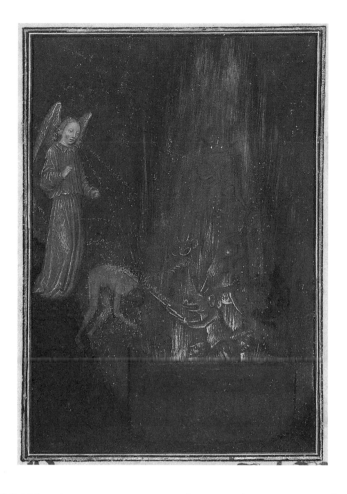

PLATE 12. *The Cistern of Hell (fol. 29)*

And thus they started to walk the remainder of their way, descending into Hell. As they were walking together, talking to each other, a great dread and horror suddenly came upon the soul of the knight, and he started to shiver and tremble so violently that he could not hold himself up. As they entered into complete gloom, such as they had never seen, the soul said to the angel, "Oh dear master, how can it be that I cannot stand up?" But the angel would not answer him or give him any comfort. And thus, while the poor soul was in such despair and peril, he heard great and horrible shouts, howls, and screams, so fierce that no tongue could describe them, no ear hear them, and no heart imagine them. Looking here and there, he saw a great pit, all square, in the shape of a cistern. From that pit was issuing a whirl-wind of flame, terribly foul smelling. Inside the steam and whirlwind was a very great number of devils, and also of souls who were scrambled with them in the flame. When these souls had ascended quite high up, they would suddenly fall, all at once, to the depths of the furnace.

When the soul of the knight had seen this torment, he wanted to move away, but he could not lift his feet from the ground because of his great fear. When he saw that his will could not be fulfilled, he got very angry and said to himself, "Alas, miserable one, why did you not want to believe in the Scriptures?" When the devils, who were cavorting in the flames, heard him lamenting thus, they came at once and, grasping their instruments, seized the desolate soul, who was without any defense, and threw him into the furnace, saying with one voice, "From now on you will see the torments your actions have deserved, from which you will never be able to escape. Although dying of torment, you will not be able to die. The one who led you here has deceived you." Then they said to each other, "Let us drag this soul with us. Let us give him to our prince, Lucifer, to devour." And as they were threatening the suffering creature with eternal death, they grew blacker than fury itself and more excited than rabid dogs. But then the angel returned, and he drove away all those fiends, and he again comforted the soul as he had done before. The angel thereupon said, "Come forward and I will show you the very detestable and horrible ancient enemy of the human race."

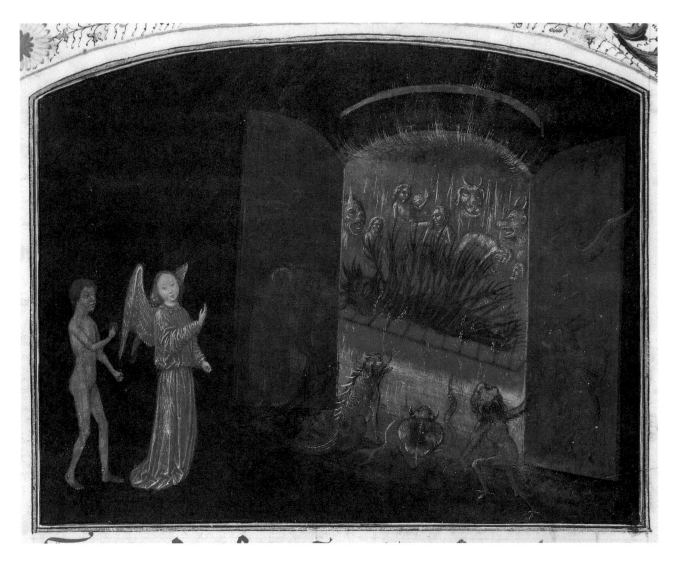

PLATE 13. *Lucifer, Prince of Hell (fol. 30v)*
The angel then went ahead first, and the soul after
him. They went a distance until they reached the
gate of Hell. The angel then said to the soul, "Come
and look." The soul approached until he saw the
great gate of Hell. He saw, quite clearly, the prince
of Hell, the enemy of the world, the miserable devil
who was larger than any of the beasts they had
seen before. He was blacker than coal and more
ablaze than a thousand burning fires. He had the
shape of a man from the feet to the head, but he had
many hands and feet. In fact, he had ten thousand
hands, each of which had twenty fingers, and each
finger was one hundred palms long and ten palms
thick. The nails were longer than the lances of
knights, and they were of fine steel. And he had as
many toes and toenails. Moreover, the beast had
several long and sharp beaks and a tail full of spikes.
This horrible devil stretched his back against a
great gridiron, beneath which were coals all blazing
in great abundance. Around this perverse enemy was
a multitude of damned souls, all mixed with devils.
This horrible enemy was bound to the grate with big
iron chains. When his nails and claws were full of
unhappy souls, he squeezed them as harshly as the
press that extracts wine. Then he exhaled his breath
and ejected these forlorn souls into Hell's torments.

That very cruel beast then inhaled, and together
all the souls that he had cast into Hell returned into
his jaws.

The soul of the knight said to the angel, "I beg
you, dear master, to tell me what is the name of this
very horrible Satan?" The angel answered, "He is
named Lucifer, and he was the first of the creatures
created by Our Lord, and the most beautiful and the
most powerful. He was once in a great position in
Paradise, but through his very great pride and pre-
sumption he wanted to elevate himself and proclaim
himself equal to his Creator. And for this, God
made him fall down to the depths of Hell, and there
had him chained, as you can see. Among this multi-
tude of souls are those who had no hope in the mercy
of God, who do not believe firmly in Jesus Christ, or
who commit acts of evil. Thus will suffer also those
who want to be kings or emperors, not to uphold
goodness but to reign over others." Then the soul
said, "I recognize amidst the torments several of my
relatives and many of my companions, but I am
afraid to acknowledge them. For this reason, I humbly
pray you, that you would lead me out of here." To
which the angel said, "Come forward with assurance.
You have seen up to now the tribulations of the
unfortunate damned in Hell, but from now on you
will see the glory and light of God, Our Lord."

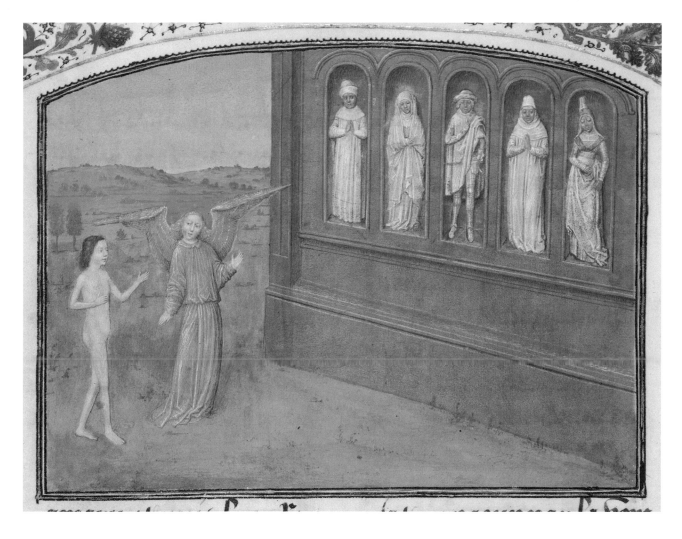

PLATE 14. *The Bad But Not Very Bad (fol. 33v)*
The angel and the soul of Tondal passed through
much darkness until they found themselves in a clear
place where light appeared to them, followed by a
great luminance. Then the soul became so full of
elation and joy that he was immediately cured of all
pains. The two walked a long way until they came
upon a very high wall. Ensconced in the wall was a
great multitude of men and women who, night
and day, were exposed to wind and rain and felt great
pain, especially from hunger and thirst. But they
were in the light, and they did not smell any foul
odor. The soul asked the angel, "Who are these
people who live in this place without undergoing
torments?" The angel answered, "They are those
who, while in the world, did not commit great evil,
and who behaved honestly. But the worldly goods
that God had lent them to give to the poor, they did
not share as faithfully as they should have. And for
this they have deserved to endure wind and rain for
as long as it pleases God. Later they will be taken to
a place of rest."

Quant langele ot reconforte lame du challier come dit est ilz alerent vng petit plus avant et tantost vindrent a vne porte qui leur ouury delle meismes Et quant ilz furent entrez en icelle porte ilz varent vng champ tout bar

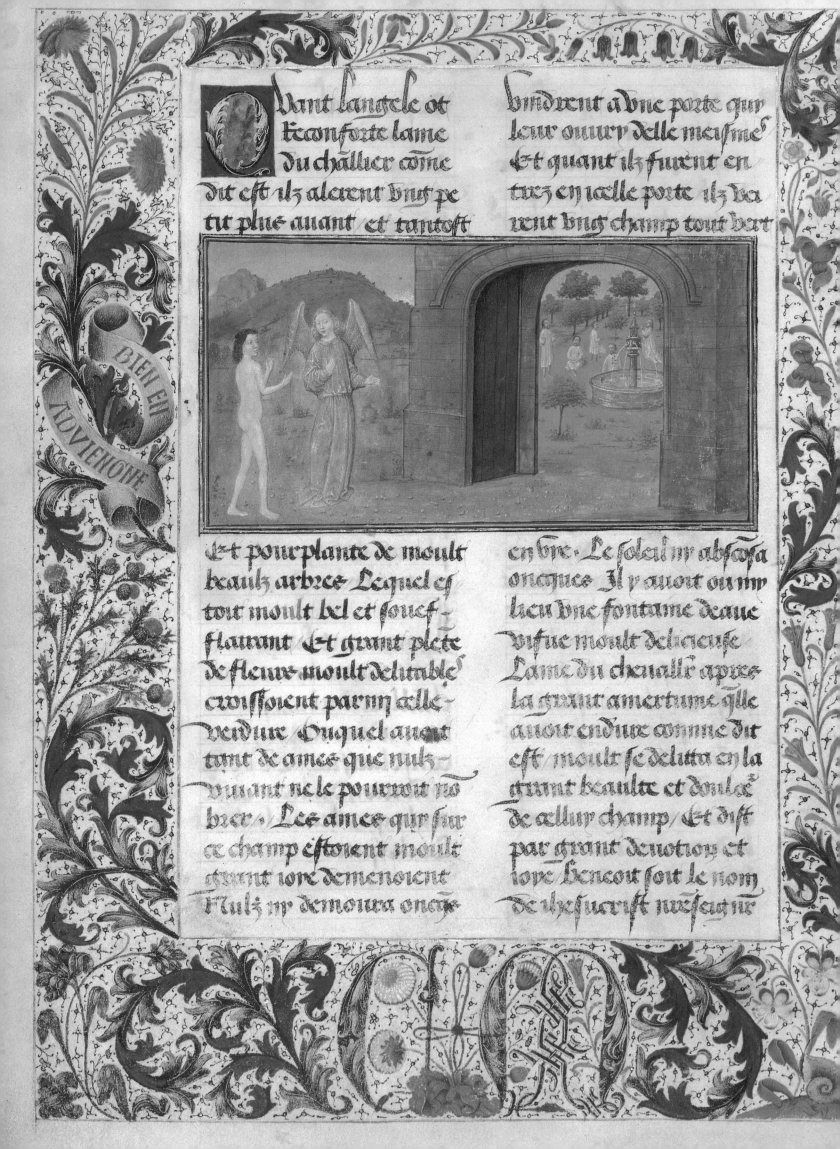

Et pourplante de moult beaulz arbres Lequel estoit moult bel et souef flairant Et grant plete de fleurs moult delitables croissoient parmy celle verdure Ouquel auoit tant de ames que nulz viuant ne le pourroit nobrer Les ames qui sur ce champ estoient moult grant ioye demenoient Nulz ny demoura oncq en bre Le soleil ny abscosa oncques Il y auoit ou my lieu vne fontaine deaue viue moult delicieuse Lame du cheuallr apres la grant amertume qlle auoit endure comme dit est moult se delitta en la grant beaulte et doulce de cellur champ Et dist par grant deuotion et ioye Beneoit soit le nom de ihesucrist nreseigneur

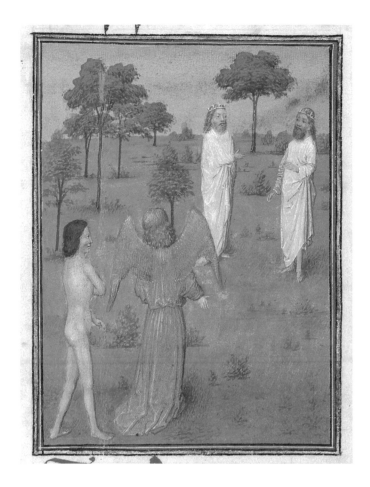

PLATE 15. *The Good But Not Very Good (fol. 34v)*
Then they went a little farther, and soon came to a
gate that opened for them by itself. When they had
entered the gate they saw a field, all green and
planted with many beautiful trees, that was very
lovely and sweet smelling. A great abundance of very
delightful flowers was growing among the greenery
where there were so many souls that no living man
could count them. The souls were disporting them-
selves in great joy, more than they ever did in life.
The sun was never hidden. There was in the middle
a fountain of delicious running water. The soul of the
knight was quite delighted. Out of deep devotion,
he said, "Blessed be the name of Jesus Christ, Our
Lord, because He has delivered me from the gates of
Hell and let me today reach the gate where His
good friends are living." Then the soul asked the
angel, "But who are the souls who are resting around
the fountain?" The angel answered, "In this place
are living those who are not very good. They are
preserved from the torments of Hell; however, they
are not yet in the company of the saints. The fountain
that is here is called 'living' because he who drinks
from it will live forever and will never thirst."

PLATE 16. *King Conchober and King Donatus (fol. 35)*
Soon the angel and the soul saw two kings who
had died not so long ago. The soul said to the angel,
"These two great princes were much feared in
their time, and they were great enemies. How have

they deserved to come here?" The angel answered,
"They made peace between themselves and repented
all the trespasses of their earthly lives. King Con-
chober languished for a long time before his death
and vowed that if he regained his health he would
enter religious life. King Donatus was in jail for a
long time and gave away all that he had to the poor."
The angel and the soul then came upon a castle
that had neither doors nor windows, but whoever
wanted could enter. Inside, it was long and wide and
paved with fine gold and precious stones. The soul
saw therein a throne draped in cloth of gold and silk,
on which sat King Donatus. Then several servants,
dressed in ornate robes, placed before the king
goblets, vessels of gold and silver, and ivory caskets
in abundance. Thereupon, the soul said, "Master,
I marvel at the number of servants who have come
here to our king, but I cannot recognize a single one
who served him when he was alive." To which the
angel said, "All these whom you see are the poor to
whom he gave his worldly goods. Because of this,
a reward is returned to him that will never cease."

The splendid castle then became all dark and full of
gloom, and the soul saw the king burning in fire up to
his navel and clothed in a hair shirt. "Every day," said
the angel, "for three hours he endures this torment,
and for twenty-one hours he is at rest. Because he did
not keep his marriage faithfully, he burns in that fire.
He wears a hair shirt because he ordered a man killed.
All his sins have been forgiven except these two."

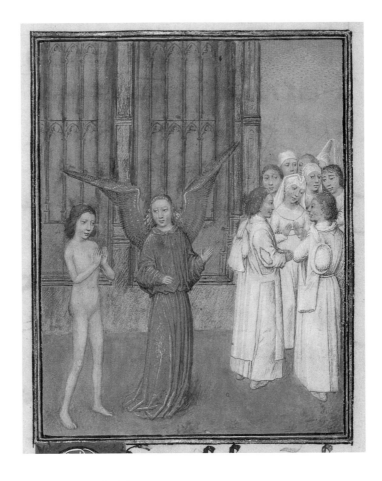

PLATE 17. *The Joy of the Faithfully Married (fol. 37)*
The angel and the soul of Tondal left that place and
came upon a wall, very tall and shining. The wall was
of solid silver, well wrought and very handsome. But
the soul could see no door. He then looked around
and saw (I know not how) a beautiful and large
assembly of saints, male and female, who were
expressing great joy in God. Clothed in white robes,
they were very handsome, without blemish and
without any imperfection. Their voices harmonized
together like a sweet melody made by musical instru-
ments. The sweetness of the air surpassed all the
perfumes and spices that ever were. In that place
there were no cares or troubles.

"Dear master," said the soul, "for whom is this
place prepared?" "For those," said the angel, "who
have kept their faith and loyalty in marriage and who
have rightly given their worldly goods to the churches
and to the poor." "Dear master," then said the soul,
"I beg of you, if it is possible, that I could remain
forever in this joy. I want to stay in this company. I
do not wish to have better." "You have not yet
deserved this," said the angel, "but you will see an
even greater happiness and glory." Then the good
angel and the soul walked on. All those who belonged
to that company would bow before the angel and call
the soul by name, praising Our Lord who, out of His
compassion, had preserved him from the eternal fire.

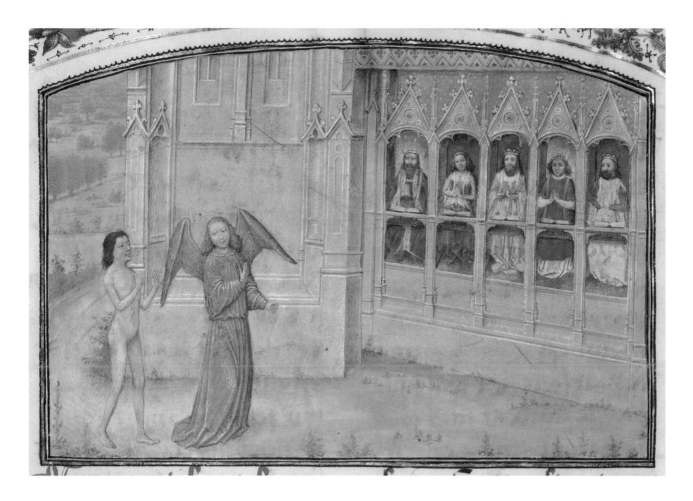

PLATE 18. *The Glory of Martyrs and the Pure (fol. 38v)*
When the good angel and the soul of the knight had
left the glory of those in the state of marriage, they
chanced to see from afar another great wall, very high
and long, rather similar to the one already spoken of.
But this wall was entirely made of fine gold. When
they had passed this very noble wall, they came upon
several very sumptuous thrones that were all made
of gold and silk. Upon these thrones were sitting men
and women all dressed in silk cloth and white stoles.
Each wore a crown on his head and all kinds of
other rich ornaments, the equal of which the soul had
never seen. The face of each was shining like the
sun at the hour of noon. Their hair was like fine gold,
and they had in front of them books written in
letters of gold. They were singing "Alleluia" to Our
Lord. When the soul had listened for a little to
that sweet song, he forgot all that he had seen.
Then the angel said to him, "Here are those who
have delivered their bodies to martyrdom for the love
of Our Lord, and who washed their stoles in the
blood of the Lamb. These are also those who crucified
their flesh against the vices and lusts of the world.
And for this they have well deserved the crown
of victory. These are the ones who have become the
friends of God."

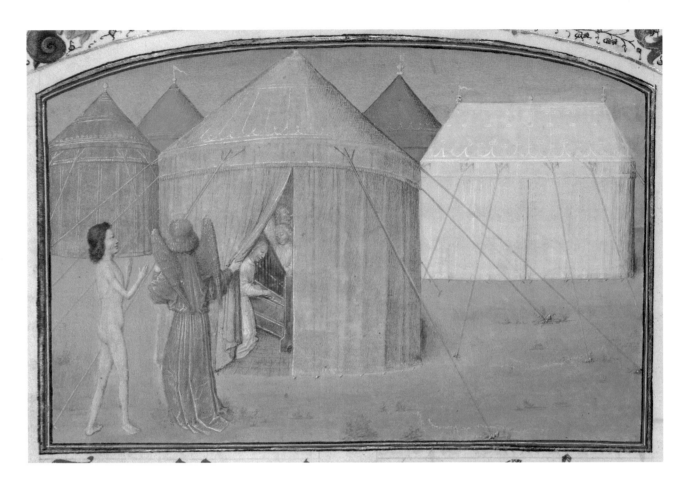

PLATE 19. *The Glory of Good Monks and Nuns*
(fol. 39v)

Thus leaving the company of the martyrs, the good angel and the soul of the knight went along until they reached a very delightful place. The soul looked around and saw erected there numerous tents and pavilions, made of royal purple and silk. From inside these tents and pavilions, the soul clearly heard singers who were chanting very sweetly. Then the angel said, "These songs and the music of the instruments, so melodious, are the comfort and glory of the monks and nuns, and of all religious who in their time in the world have lived in complete obedience and chastity. They rendered, by their good works, what they had promised to their prelates, and they had greater joy in being under the rule of others than in being rulers themselves. They also guarded their tongues from evil words. These are the ones who have the pretty pavilions and glorious seats." "Master," then said the soul, "I would indeed like to go closer to look upon those who are inside." To which the angel said, "Do not enter where they are. The ones here see before them the presence of the Holy Trinity, and whoever once is able to enter forgets everything of the past and would never

be able to leave the company of the saints unless he were a virgin who deserved to be in the company of angels."

They then came a little closer to the men and women who looked like angels. The light from these souls, their perfume, and the delectable sound were greater than all the glory that the soul had previously seen. There were all kinds of instruments that were playing by themselves. Suspended there were chains of gold interspersed with little silver bars. From these chains were hanging fleurs-de-lis, phials, beads of gold, and other flowers. Flying about was a very great multitude of angels, making a marvelous sweet sound to those who were able to hear them. The soul was delighted with this noble sight, and he would have liked to stay there forever.

.

They came to a tree, tall and wide, laden with fruit. Resting under the tree were men sitting on seats of gold and ivory. Each had a crown and scepter of gold and was clothed in a rich cope. The angel explained, "This tree is the image of the Holy Church, which these people devoted all their effort to build and defend. They come here to rejoice and praise Our Lord."

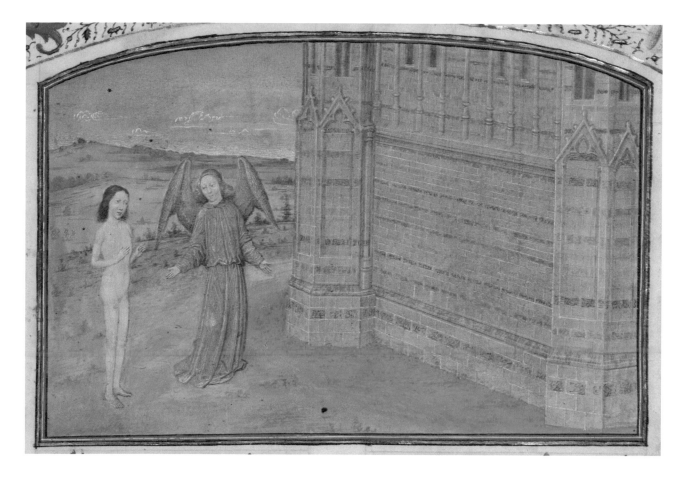

PLATE 20. *The Glory of Virgins and the Nine Orders of Angels (fol. 42)*

When they had gone a little farther, they saw a wall that was so high and beautiful and resplendent that all the others were nothing in comparison. This wall was wrought with precious stones of assorted properties and numerous colors. Its metal was so intermingled with them that it shimmered as if aflame, and its mortar, indeed, resembled fine gold. The names of these precious stones were: crystal, jasper, chrysolite, hyacinth, sapphire, emerald, onyx, topaz, sardonyx, chrysoprase, amethyst, and garnet. This wall was so bright and shiny that it would ward off any displeasure or trouble, and it would inspire with consolation and joy the hearts of those who looked upon it. O how great are the things prepared by Our Lord for those who love Him, because they will see the orders of the blessed angels, the archangels, the virtues, the powers, the dominations, the thrones, the cherubim, and the seraphim!

Then the angel said to the soul, "You are clearly able to contemplate how great a consolation one can have being in the company of patriarchs, prophets, angels, apostles, martyrs, confessors, and virgins." And there, where the soul was, not only could he see the glory that he had seen before, but he could also view the whole world, as if under a single ray of the sun. Then he said to the angel, "Please, dear master, I pray you that I could stay here forever." The angel answered him, "You must return to your body. Remember well all that you have seen during this pilgrimage, for the benefit of those close to you and of your own salvation." When the soul saw that he had to return, he was very sad and, crying, asked the angel, "Did I commit so much evil during my life that I have to relinquish the glory of the place where I am standing and return to my miserable body?" Then the angel answered him, "Once, you did not want to believe Scripture, and because of that you will not stay in this glory. Return to your body from which you departed. Turn away from those evil deeds you used to commit and pursue. Do thus, and my guidance will never fail you." Suddenly, when the angel had said this, the soul felt himself reburdened with the weight of his body at the house of his friend where previously he had left it. Thereupon the knight opened his eyes and asked to be given Communion, which he received devoutly. He donated all his worldly goods to the poor and ordered the sign of the Cross put upon all his garments. He recounted to those who were present the things he had seen during this voyage and exhorted each of them to lead a good and honest life. And he who previously did not know or want to hear about God was preaching from then on with great devotion.

Description of the Manuscript
Malibu, J. Paul Getty Museum, Ms. 30

Written by David Aubert (active 1456–1479) for Margaret of York, Duchess of Burgundy, at Ghent, March 1474; illumination attributed to Simon Marmion (active 1450–1489).

Vellum, 45 leaves. Single leaves mounted on guards and bound; 36.3 × 26.2 cm (14⁵⁄₁₆ × 10⁵⁄₁₆ in.). Text area 24.4–24.9 cm × 16.3–16.8 cm (9⁵⁄₈–9¹³⁄₁₆ in. × 6⁷⁄₁₆–6⁵⁄₈ in.), two columns, twenty-eight lines. Old French text in *bâtarde* script. Fifteen two-column miniatures, five one-column miniatures, fifteen full-page decorated borders, five borders in outer margins only, numerous one- to three-line illusionistic gold foliate initials. Modern brown calf binding over pasteboard.

Provenance: Margaret of York, Duchess of Burgundy (1446–1503); Marquis de Ganay, acquired in 1853 (sale, Paris, Hôtel des commissaires-priseurs, Maurice Delestre, May 12–14, 1881, lot 39); Comte de Lignerolles (sale, Paris, Librairie Charles Porquet, 1894, lot 17); Baron Vitta; Baron de Brouwer, Manoir du Relais, Pommeroeul (Hainaut); [to Librairie Fl. Tulkens, circa 1944]; [to H. P. Kraus, New York]; to Philip Hofer, Cambridge, Massachusetts, in 1951 (his Ms. Typ 234H); private collection, United States.

Selected Bibliography

On "The Visions of Tondal" and Its Tradition

Gardiner, Eileen. *Visions of Heaven and Hell Before Dante*. New York, 1989.

Le Goff, Jacques. *The Birth of Purgatory*. Chicago, 1984.

Owen, D. D. R. *The Vision of Hell: Infernal Journeys in Medieval French Literature*. Edinburgh and London, 1970.

Palmer, Nigel F. *"Visio Tnugdali": The German and Dutch Translations and Their Circulation in the Later Middle Ages*. Munich and Zurich, 1982.

Patch, Howard Rollin. *The Other World According to Descriptions in Medieval Literature*. Cambridge (Mass.), 1950.

Picard, Jean-Michel, trans. *The Vision of Tnugdal*. Introduction by Yolande de Pontfarcy. Dublin, 1989.

Wagner, Albrecht. *Visio Tnugdali, lateinisch und altdeutsch*. Erlangen, 1882.

Zaleski, Carol. *Otherworld Journeys: Accounts of Near-Death Experience in Medieval and Modern Times*. New York and Oxford, 1987.

On Margaret of York and the Burgundian Court

Armstrong, C. A. J. "The Piety of Cicely, Duchess of York: A Study in Late Medieval Culture." In *England, France and Burgundy in the Fifteenth Century* (London, 1983), pp. 135–156.

Banque de Bruxelles. *Marguerite de York et son temps*. Ex. cat., Brussels, 1967.

Cockshaw, Pierre, et al. *Charles le Téméraire*. Ex. cat., Bibliothèque Royale Albert Ier, Brussels, 1977.

Hughes, Muriel J. "Margaret of York, Duchess of Burgundy: Diplomat, Patroness, Bibliophile, Benefactress." *The Private Library*, 3rd ser., 7 (1984), pp. 2–17, 53–78.

Schryver, Antoine de. "Nicolas Spierinc calligraphe et enlumineur des Ordonnances des États de l'hôtel de Charles le Téméraire." *Scriptorium* 23, no. 2 (1969), pp. 434–458.

Smith, Jeffrey Chipps. *The Artistic Patronage of Philip the Good, Duke of Burgundy (1419–1467)*. Ph.D. diss., Columbia University, 1979.

Vaughan, Richard. *Charles the Bold: The Last Valois Duke of Burgundy*. London, 1973.

———. *Philip the Good: The Apogee of Burgundy*. London, 1970.

Weightman, Christine. *Margaret of York, Duchess of Burgundy, 1446–1503*. Gloucester and New York, 1989.

On Simon Marmion and the Manuscripts Attributed to Him

Delaissé, L. M. J. *Le Siècle d'or de la miniature flamande: Le Mécénat de Philippe le Bon*. Ex. cat., Bibliothèque Royale Albert Ier, Brussels, 1959.

Hindman, Sandra. "The Case of Simon Marmion: Attributions and Documents." *Zeitschrift für Kunstgeschichte* 40 (1977), pp. 183–204.

Hoffman, Edith Warren. "Simon Marmion Re-considered." *Scriptorium* 23, no. 2 (1969), pp. 243–271.

———. "Simon Marmion or 'The Master of the Altarpiece of Saint-Bertin': A Problem in Attribution." *Scriptorium* 27, no. 2 (1973), pp. 263–290.

Kren, Thomas, ed. *Renaissance Painting in Manuscripts: Treasures from the British Library*. New York, 1983.

Schryver, Antoine de. *Gebetbuch Karls des Kühnen vel potius Stundenbuch der Maria von Burgund. Codex Vindobonensis 1857 der Österreichischen Nationalbibliothek*. With a codicological introduction by Franz Unterkircher. Graz, 1969.

Sterling, Charles. "Un Nouveau Tableau de Simon Marmion." *Revue d'Art Canadienne/Canadian Art Review* 8 (1981), pp. 3–18.

Winkler, Friedrich. "Simon Marmion als Miniaturmaler." *Jahrbuch der Preussischen Kunstsammlungen* 34 (1913), pp. 254–280.